RICHARD DIEBENKORN

by
Linda L. Cathcart

38th Venice Biennial, 1978
United States Pavilion

International Exhibitions Committee
of The American Federation of Arts

Distributed by
RIZZOLI INTERNATIONAL PUBLICATIONS, INC.

International Exhibitions Committee
of The American Federation of Arts

Thomas M. Messer, Chairman

© Linda Cathcart 1978
Richard Diebenkorn (essay)

© International Exhibitions Committee of
The American Federation of Arts 1978

Published by the
International Exhibitions Committee of
The American Federation of Arts

Trade edition distributed by

RIZZOLI INTERNATIONAL PUBLICATIONS, INC.
712 Fifth Avenue/New York 10019

Library of Congress Catalogue Number 78-60174
ISBN 0-8478-0202-7
Designed by Michael Shroyer
Type set by Haber Typographers, Inc., New York
Printed by Metro Graphics Corp., New York

Cover: *Ocean Park #105*, Courtesy of M. Knoedler & Co.

Contents

Preface

In response to the general theme defined by the organizers of the 38th Venice Biennial as "From Nature to Art, from Art to Nature," the International Exhibitions Committee of The American Federation of Arts has designated a painter and a photographer to share the space in the United States Pavilion on this occasion. The painter is Richard Diebenkorn and the photographer, Harry Callahan.

The transformation of Callahan's and Diebenkorn's respective perceptions into form differs greatly from each other, not only because the photographer's medium has other possibilities and limitations than the painter's craft but also because each of these two artists have developed highly personal styles rooted in temperaments and developments that are unique. For both, however, art and nature—the world of forms and images and their source in observed reality—are central pursuits. For this reason, both are natural choices to implement a broadly conceived overall theme. But also, in their respective creative areas, are practitioners of such distinction that each would come to mind under any circumstances as an ideal standard-bearer for this international event.

The International Exhibitions Committee is responsible for the implementation of such international programs as the Venice Biennial. The Committee came into being in 1976 through administrative support from the National Endowments for the Arts and the Humanities.

United States' participation in the 38th Venice Biennial was finally assured through generous grants from the National Endowment for the Arts, the United States International Communication Agency, the Cultural Office of the United States Department of State, as well as from private grants from an anonymous donor, Mr. and Mrs. Gifford Phillips, the Los Angeles Times Mirror and The Chase Manhattan Bank, N.A. All these sources and the contributions received from them are herewith most gratefully acknowledged.

Responsibility for staging this year's Venice Biennial was given to Robert T. Buck, Jr., Director of the Albright-Knox Art Gallery in Buffalo, New York who will act as Commissioner. Curators for the two exhibitions are, respectively, Linda L. Cathcart, Curator, Albright-Knox Art Gallery and Peter C. Bunnell, Director, The Art Museum, Princeton University and McAlpin Professor of the History of Photography and Modern Art. Both have been chosen because of their respective familiarity with Diebenkorn's and Callahan's work, and because of distinguished critical contributions that they have already made in these areas.

Finally, the Committee wishes to acknowledge the far-reaching administrative contributions made by Wilder Green, as Director of The American Federation of Arts, and his staff, and by Jack L. Boulton, as Acting Director of the International Exhibitions Committee.

Thomas M. Messer, Chairman
International Exhibitions Committee of
The American Federation of Arts

Proemio

In risposta al tema generale al quale gli organizzatori della XXXVIII Biennale di Venezia hanno dato il titolo "Dalla natura all'arte, dall'arte alla natura" il Comitato della Federazione Americana delle Arti per le Mostre Internazionali ha designato un pittore ed un fotografo a partecipare insieme al Padiglione degli Stati Uniti. Il pittore è Richard Diebenkorn e il fotografo Harry Callahan.

L'atto di trasformare intuizioni in forme differisce grandemente tra Callahan e Diebenkorn, non solo perchè il mezzo usato dal fotografo ha possibilità e limitazioni diverse da quelle che ha il mezzo usato dal pittore, ma anche perchè ognuno di questi due artisti ha sviluppato uno stile completamente personale che ha radici in temperamenti differenti e ha avuto sviluppi diversi. Per ambedue però, arte e natura – il mondo delle forme e delle immagini e la loro provenienza dalla realtà – sono la ricerca principale. Per questa ragione ambedue sono la scelta logica per complementare un tema globale ideato in maniera vasta. Nello stesso tempo essi sono artisti di tale distinzione, ognuno nel suo campo, che verrebbero giustamente scelti in ogni caso come rappresentanti ideali in questo evento internazionale.

Al Comitato per le Mostre Internazionali va il credito per il completamento di programmi internazionali quali la Biennale di Venezia. Questo comitato sorse nel 1976 con l'appoggio amministrativo della Dotazione Nazionale per le Arti e le Belle Lettere.

La partecipazione degli Stati Uniti alla XXXVIII Biennale di Venezia è stata assicurata a mezzo di generose donazioni da parte della Dotazione Nazionale per le Arti, l'Agenzia Internazionale per le Comunicazioni degli Stati Uniti, l'Ufficio Culturale del Ministero degli Esteri degli Stati Uniti, come pure a mezzo di donazioni private da parte di un anonimo donatore, Gifford Phillips e Signora, del Los Angeles Times Mirror e della banca Chase Manhattan, N.A. Tutte queste fonti e i loro contributi vengono qui riconosciuti con gratitudine.

Il compito di coordinare la Biennale di Venezia questo anno è stato affidato a Robert T. Buck Jr., Direttore della Galleria d'Arte Albright-Knox di Buffalo, N.Y. nella sua qualità di Commissario degli Stati Uniti. Direttori artistici per le due mostre sono, rispettivamente, Linda L. Cathcart, della Galleria d'Arte Albright-Knox e Peter C. Bunnell, Direttore del Museo d'Arte dell'Università di Princeton e McAlpin Professor di Storia della Fotografia e di Arte Moderna. Essi sono stati scelti per la loro conoscenza, rispettivamente, dell'opera di Diebenkorn e Callahan e per il considerevole contributo critico da loro fornito in questo campo.

Infine il Comitato desidera riconoscere il contributo amministrativo di vasta estensione fornito da Wilder Green, Direttore della Federazione Americana per le Arti e dal suo personale, e da Jack L. Boulton, Direttore Supplente del Comitato delle Mostre Internazionali.

Thomas M. Messer, Capo del
Comitato della Federazione
Americana delle Arti per le
Mostre Internazionali

Introduction

"From Nature to Art and from Art to Nature," the official theme of the 38th Venice Biennial, is itself descriptive of a factor of crucial importance to the humanist traditions which have played a dominant role in the history of western art since the time of the Italian Renaissance. The fact is that artists have taught us how to appreciate nature in its abundant, and even severe beauty, and the landscapes they have painted, drawn and captured have, in the process, taught us much about ourselves.

Ever since the first representation of landscape in art, the *Garden View* frescos at the Villa of Livia, c. 20 B.C., artists have sought to balance out their interest in the human figure as a central focus of their art—traditions inherited from the Greeks and Romans—with a growing awareness of nature as more than a matrix element in their work. One need only cite nature in the works of the great Venetian painters, Giorgione and Titian, and a half century before them, Conrad Witz, to understand the artist's growing sensitivity to nature as subject matter in itself, a pattern which, as set forth in their work, reaches a culmination of harmonious interaction and stylistic unity in 18th century France in the work of Watteau, Lancret, and Pater. Here the human figure is integrated into the very rhythm and organic energy of the composition's natural theme in order to emphasize the frailty of man, the temporal character of all living things, and the artist's encompassing and universal vision of the world.

In 19th century art, nature and landscape were elevated to the level of mystical powers and adulation, an extreme reaction of the overriding Romantic character of the period. The result, notably in the works of the northern Romantic artists such as Friedrich and Runge was to sanctify nature, making it appear altogether other-worldly, a place none of us had rarely, if ever, been to.

It is, I believe, with considerable acumen of purpose that the International Exhibitions Committee in America chose the works of Richard Diebenkorn and Harry Callahan as the United States representation to the 38th Venice Biennial, celebrating the naturalistic theme. The works of both men embody the dilemmas and delights of the artist's use of nature as a compelling and centralizing force in artistic creativity of recent times.

In the 19th and early 20th centuries, American artists had long and faithfully followed traditional European approaches to stylistic development; the dramatic break from tradition came with the New York School of painters. Although both never really lived in New York, Diebenkorn and Callahan as young artists participated through their early work of the 1940s in this period of terrific excitement, flux, and searching for originality in order to break with past tradition. Artists older than they were acquainted first-hand with many distinguished European artists who had taken up residence in the United States during World War II, such as Léger, Ernst, and Mondrian. In the example of Mondrian's *de Stijl* statements, one had an entire new esthetic of essentially cubist-constructivist interpretation of what he insisted always was only *naturalistic art* at root, or gradual evolution of form from landscape.

The answers in America, nonetheless, first came from another direction to young artists—out of the surrealist, autonomous gesture freely reinterpreted and gradually pried loose from any programmatic or narrative mission—and resulted in the creation of the celebrated *abstract expressionistic* styles.

Both Diebenkorn and Callahan share much with these artists, but most of all they share their steadfast devotion to a sense of purity of purpose and image, refusing at any point to subject their art to goals of social realism, doctrine or mere documentation. The precedents were clear—for Callahan, Adams and Weston; for Diebenkorn, Still and de Kooning—and their convictions as young artists to pursue an honest and unfettered art were just as great.

Striking as well in the choice of these two artists to represent the United States in Venice this year is their similarity of character. Both artists are men of few words upon whose careers a small number of great influences have had an effect. Both are deeply admired by those of the same professional persuasion to the point of correctly calling Diebenkorn "a painter's painter" and Callahan "a photographer's photographer." But at a certain point the similarities cease, only superficial after all, and one is aware instead of the individual and deeply independent contribution of each.

They grapple with their own continuing visions with a sense of the artistic past and present uniquely their own. In Callahan's *Nude and Landscape* series of photographs, remembrances of Giorgione's *The Tempest* and *Sleeping Venus* are evoked. Diebenkorn's *Ocean Park* paintings, clearly rooted in landscape, suggest delineation of spaces and structuring wherein the painter's admiration of Mondrian and early Matisse is fundamental to understanding his real achievement.

I wish to thank Linda L. Cathcart, Curator of the Albright-Knox Art Gallery, Buffalo, and organizer of the section of Diebenkorn paintings for the Biennial, for her exemplary and able work and extend my thanks as well to Peter C. Bunnell, Director and Curator of Photographs, The Art Museum at Princeton University, who with skill and insight has organized the section of Callahan photographs.

I further wish to acknowledge the support for this project of Thomas M. Messer, Chairman of the International Exhibitions Committee, and the other members of the Committee. The artists have aided extensively in providing their cooperation and advice, even at relatively short demand.

I am especially grateful for the following private contributions in support of the American section of this year's Venice Biennial: an anonymous donor, Mr. and Mrs. Gifford Phillips, the Los Angeles Times Mirror and The Chase Manhattan Bank, N.A.

Finally to the viewer, my sincerest wish that their enjoyment of the exhibitions be as great as that of those who had the duty and pleasure of organizing them.

Robert T. Buck, Jr.
United States Commissioner
38th Venice Biennial, 1978

Introduzione

"Dalla natura all'arte, dall'arte alla natura"; il tema ufficiale della XXXVIII Biennale di Venezia è in se stesso un richiamo ad un elemento di cruciale importanza nelle tradizioni umanistiche che hanno giocato un ruolo dominante nella storia dell'arte occidentale, a cominciare dal Rinascimento italiano. E vero, infatti, che, mentre da un lato gli artisti ci insegnano ad apprezzare la natura nella sua multiforme e, talvolta, aspra bellezza, dall'altro i paesaggi che hanno dipinto, disegnato o comunque fatto propri, ci insegnano ad approfondire la conoscenza di noi stessi.

Da quando le prime vedute naturali hanno fatto apparizione nell'arte – gli affreschi della *Vista sul giardino* della Villa di Livia del 20 A.C. – gli artisti hanno costantemente cercato un equilibrio fra la figura umana, eterno punto focale di qualsiasi opera, secondo la tradizione ereditata dai Greci e dai Romani, e la crescente consapevolezza che la natura era qualcosa di più che una "matrice." Basta pensare al paesaggio nei grandi Veneziani, Giorgione e Tiziano, e, mezzo secolo prima, a Corrado Witz, per cogliere la progressiva percezione della natura come tema artistico in sé. E una tendenza che, una volta delineatasi, culmina poi nell'armoniosa integrazione e unità stilistica nella Francia del XVIII secolo, nell'opera di Watteau, Lancret e Pater. Qui la figura è addirittura inserita nel ritmo stesso degli elementi paesaggistici della composizione e partecipa dell'energia organica che da questi sprigiona. Così sono poste in risalto la fragilità umana, la temporaneità di tutte le cose viventi e la visione universale dell'artista.

Nel XIX secolo la natura e il paesaggio furono posti su un piedistallo di mistica potenza: era l'estrema conseguenza del Romanticismo imperante in quel periodo. Il risultato, specialmento nelle opere dei Romantici nordici come Friedrich e Runga fu di santificare la natura, facendola apparire come d'un altro mondo, un luogo quasi mai, o meglio mai, visto da nessuno.

Credo, quindi, che l'*International Exhibition Committee* in America, con la sua decisione di inviare le opere di Richard Diebenkorn e Harry Callahan a rappresentare gli Stati Uniti alla XXXVIII Biennale di Venezia, abbia colto appieno il significato della manifestazione, che celebra appunto il tema naturalistico. Diebenkorn e Callahan incarnano entrambi la visione tormentosa e insieme edonistica della natura come forza dominante e centripeta comune alla creatività artistica dei tempi più recenti.

Durante tutto il XIX e al principio del XX secolo, gli artisti americani avevano seguito fedelmente gli esempi europei in fatto di sviluppo stilistico: la *New York School* portò ad un taglio netto con la tradizione. Diebenkorn e Callahan, anche se nessuno dei due si può dire sia vissuto veramente a New York, parteciparono da giovani, coi loro primi lavori degli anni quaranta, a questo momento di fermento straordinario, in cui sfociavano energie tutte tese alla ricerca di espressioni originali, liberate dalla tradizione del passato. Altri artisti più anziani di loro avevano conosciuto personalmente molti illustri maestri europei che si erano stabiliti negli Stati Uniti durante la seconda guerra mondiale, come Léger, Ernst, Mondrian. Il *de Stijl* di Mondrian offriva l'esempio di una estetica completamente nuova basata su un'interpretazione essenzialmente cubista-costruttivista di quella che Mondrian insisteva essere semplicemente arte naturalistica alla radice, ovvero progressiva evoluzione della forma dal paesaggio.

Eppure, in America, gli artisti della nuova generazione trovarono la risposta in un'altra direzione: nell'espressione surrealista, liberamente interpretata ed esplorata sempre più a fondo prescindendo da qualsiasi intenzione programmatica o descrittiva. Il risultato fu la nascita del famoso stile *astratto-espressionista*.

Sia Diebenkorn che Callahan hanno parecchi tratti in comune con questo gruppo: sopratutto una incrollabile fedeltà alla purezza dell'ideale e dell'immagine, che implica il rifiuto di assoggettarsi a qualsiasi intento dottrinario, di realismo sociale o di mera documentazione. I precedenti erano chiari: per Callahan, Adams e Weston, per Diebenkorn, Still e de Kooning. La loro aspirazione giovanile verso un'arte onesta e libera da pastoie era altrettanto profondamente sentita.

La scelta di questi due artisti come rappresentanti degli Stati Uniti a Venezia colpisce anche perchè fra loro si assomigliano. Entrambi sono uomini di poche parole che hanno sentito l'influenza soltanto di pochi grandi maestri. Entrambi riscuotono profonda ammirazione fra gli artisti nel loro campo, tanto da essere soprannominati, Diebenkorn, "il pittore dei pittori" e, Callahan, "il fotografo dei fotografi." Ma la somiglianza arriva solo fino ad un certo punto, non oltre la superficie, e l'opera di ciascuno appare chiaramente personale e indipendente.

Ognuno di loro sente il passato e il presente a modo suo e li traduce in una propria, personale espressione. Nella serie fotografica *Nude and Landscape* di Callahan vibrano echi della *Tempesta* e della *Venere addormentata* di Giorgione. La serie pittorica *Ocean Park* di Diebenkorn, chiaramente ispirata al paesaggio, rivela una delimitazione e strutturazione degli spazi la cui spiegazione di base sta nell'ammirazione del pittore per Mondrian e per il primo Matisse.

Desidero ringraziare Linda L. Cathcart, conservatrice della Albright-Knox Art Gallery di Buffalo, che ha organizzato la sezione della Biennale dedicata a Diebenkorn, per il suo esemplare professionalismo, e Peter C. Bunnell, direttore, e conservatore del reparto fotografico, dell'Art Museum della Princeton University, alla cui capacità e intelligenza si deve la sezione Callahan.

Voglio inoltre esprimere il mio riconoscimento a Thomas M. Messer, Presidente dell'International Exhibitions Committee e a tutti i membri del Comitato, per l'appoggio prestato all'iniziativa. Gli artisti stessi, del resto, vi hanno contribuito largamente, pronti come sono stati, anche quando il tempo stringeva, a dare aiuto e consiglio.

Sono in particolar modo grato per i seguenti contributi privati forniti alla sezione americana della Biennale di Venezia di quest'anno da: un anonimo donatore, Gifford Phillips e Signora, Los Angeles Times Mirror e Chase Manhattan Bank, N.A.

Infine a tutti i visitatori vada il mio augurio di trovare nella mostra lo stesso godimento spirituale che ha dato a chi ha avuto il dovere e il piacere di organizzarla.

Robert T. Buck, Jr.
Commissario degli Stati Uniti per la XXXVIII Biennale

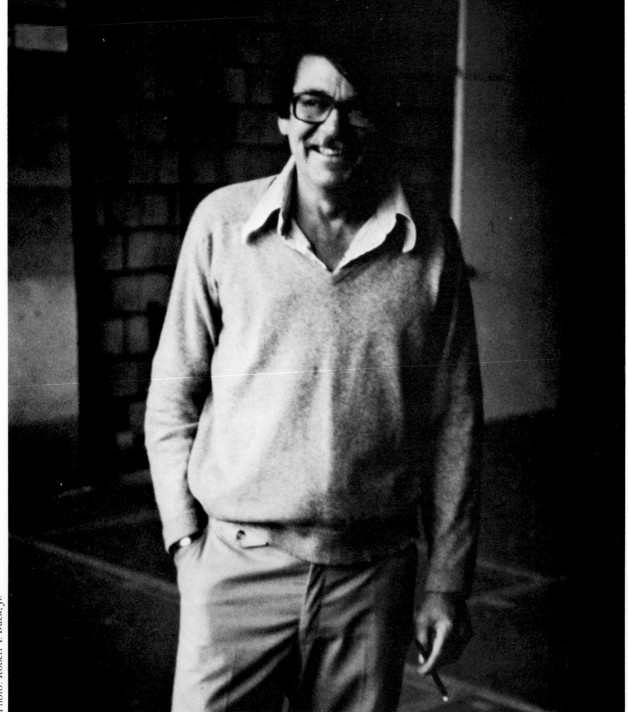

Richard Diebenkorn

The privilege of leisurely examination has recently been afforded the admirers of Richard Diebenkorn's work. Dieben-korn has never been neglected as a painter—he began to exhibit before he finished school and has continued to show regularly since then. Each of his successive series of paintings has been exhibited and the resultant reviews and writings have been overwhelmingly positive.

On the occasion of this exhibition of paintings from the *Ocean Park* series we have, once again, an opportunity to reflect on the career of this remarkable painter.

Born in Portland, Oregon in 1922 Richard Clifford Diebenkorn, Jr. was the only child of Dorothy and Richard Diebenkorn. When he was two years old, the family moved to San Francisco—an area which was to be Diebenkorn's home base until 1967 when he moved to Santa Monica where he continues to live and work. Diebenkorn's maternal grandmother Florence Stephens, a close family member, was a remarkable woman and was interested in all the arts— poetry, painting and literature. She encouraged Diebenkorn to read widely during the many summers he spent with her. Later the family cook would supply him with art materials and he would illustrate adventure stories inspired by the books his grandmother had recommended. As an adolescent, Diebenkorn was not encouraged by his parents or at the progressive high school he attended to experiment with art; he nevertheless continued to draw at home.

Enrolling at Stanford University in nearby Palo Alto, and discouraged by his father from taking an art major, he chose instead a general undergraduate program. Soon he was deeply involved with music, history and literature, particularly with the writings of Faulkner, Hemingway and Sherwood Anderson and in his third year he ventured to enroll in several art classes. Daniel Mendelowitz and Victor Arnautoff taught him oil painting and watercolor technique. They introduced Diebenkorn, through slides and book reproductions, to the works of Arthur G. Dove, Edward Hopper, Reginald Marsh and Charles Sheeler. They also encouraged him to work both in the studio and out-of-doors from nature. While he was a student at Stanford, Diebenkorn met his wife-to-be Phyllis Gilman; they were to be married in 1943.

Much of Diebenkorn's very early work has either been lost or destroyed by the artist: Diebenkorn described his first oil painting as being a "surrealist landscape, bleak and simple, with a cube for the sun and moon—a bit forced."[1] The earliest extant painting, however, is a beautiful and accomplished homage to Edward Hopper. *Palo Alto Circle,* 1943 is a small canvas divided horizontally into three parts; the sky, a hotel and a foreground—containing a railroad track and a chain link fence. It recalls Hopper's use of the cropped view, strong light and shadow and static composition but it is also embued with Diebenkorn's own inventions.

> There are personal elements that are utterly foreign to Hopper's way of seeing, such as the coincidence of the upper edge of the foreground [fence] railing. This device, fusing spatially separated planes into one flat surface, is a remarkable invention for a student and would have been even if Diebenkorn had known Cézanne well at the time.[2]

By 1943, World War II had begun and that summer Diebenkorn enlisted in the Marine Corps. The following fall the Marines enrolled him in the University of California at Berkeley as a physics and art student. His art teachers were Worth Ryder, Eugene Neuhaus and Erle Loran. Loran was a critic as well as a painter and had been a student of Hans Hofmann's. He was more intellectual in his approach to art then Diebenkorn's previous teachers. Diebenkorn found that Loran's criticism and questioning helped him gain the independence he would need to work and study while he was stationed on the East Coast during the next two years.

After a training period, Diebenkorn was stationed at the Marine base in Quantico, Virginia near Washington, D.C. There he began to paint again and drew portraits of his fellow Marines.[3] He made frequent trips to Washington to visit The Phillips Collection which includes superb examples by Bonnard, Braque, Matisse and Picasso. This exposure to the European masters brought another dimension to the young Diebenkorn's broadening vision. He was particularly impressed by Matisse's *The Studio, Quai St. Michel,* 1916. Matisse's use of architectural elements to define and relate the different planes of the painting made a lasting impression on Diebenkorn.

> This contrast, which allows a painter to emphasize the tangibility of space and evanescence of light, was deeply congenial to Diebenkorn, who would later fuse not only interiors and exteriors, but also still lifes with landscapes with figurative elements.[4]

While in Virginia, Diebenkorn also visited the A.E. Gallatin Collection, housed in The Philadelphia Museum of Art, where he saw Arp, Cézanne, Klee, Matisse and Miró. Maurice Tuchman has written that Arp's collages with their biomorphic shapes, and Klee's and Schwitters' works with their "spatial compartmentalizing" and "whimsical...and quasi-geometrical configurations,"[5] intrigued Diebenkorn.

Although he was living on the East Coast, Diebenkorn did not have much information about the activities of the New York artists. By chance he saw several copies of *DYN* magazine in which works by Motherwell[6] and Baziotes were reproduced.

> This, at a time when I was looking at French modernism, hit me kind of hard. It related curiously to that and yet it wasn't that[7]...There's a whole generation left out by Motherwell, for example Dove.[8]

Both Baziotes' and Motherwell's paintings of this period were redolent of Surrealism. While Diebenkorn's pictures of this time were somewhat reminiscent of Surrealism they reflected equally the Cubist structuring which he had learned from studying Cézanne and Picasso.

Released from the Marines in 1945, Diebenkorn returned to San Francisco to study at the California School of Fine Arts (now the San Francisco Art Institute). The director was the energetic and innovative Douglas MacAgy; regular faculty included Elmer Bischoff, David Park and Hassel Smith and visiting faculty, Ad Reinhardt, Mark Rothko and Clyfford Still.

Diebenkorn did not have much personal contact with Still whose one-artist exhibition at the California Palace of The Legion of Honor in 1947 had an immense impact on many of the Bay Area artists, Diebenkorn included. Rothko who was more accessible to Diebenkorn, taught two summer sessions in 1948-1949 at CSFA; he brought "...slides of the paintings of Pollock, Robert Motherwell, Adolph Gottlieb, Willem de Kooning and others,"[9] as well as "an original Dubuffet painting to show that 'art could hurt'."[10]

> Diebenkorn remarked to Gerald Nordland that a visit to the San Francisco Museum of Art "was worthwhile just to see the Rothko" painting *Slow Swirl at The Edge of The Sea,* 1943.[11]

At CSFA Diebenkorn quickly won the respect of both fellow students and faculty alike and in 1946 he won an Albert Bender Grant-In-Aid designed to encourage artists to travel to the East Coast. In the fall of that year Diebenkorn, his wife and first child Gretchen, moved to Woodstock, New York where he spent the winter painting steadily and seriously. He met the neighboring artists Bradley Walker Tomlin, Baziotes and Raoul Hague and traveled to New York City where he met Franz Kline. He visited the avant-garde Kootz Gallery and The Museum of Modern Art. He had

been, at the suggestion of David Park, reading about Miró's work and at the Modern he saw *Person Throwing a Stone at a Bird,* 1927. Later Diebenkorn would occasionally use Miró-like letters, arrows or other slightly whimsical symbols in his work; however he was often in conflict about this aspect of his work. At one time he said:

> I thought I was being non-objective–absolutely non-figurative–and I would spoil so many canvases because I found a representational fragment, a Mickey Mouse…back it would go to be redone.[12]

Perhaps more importantly, as Tuchman has noted, he studied Miró's composition and colors.

> From Miró he learned to curve a large shape, to give it whimsy and evocativeness; the sense that shapes are being stretched to the breaking point in Diebenkorn's work comes from Miró. Primarily, however, it was Miró's color, in its "weight and opacity and somberness" that affected Diebenkorn and permanently enlarged his pictorial vocabulary.[13]

The family left Woodstock in the spring of 1947 with their second child, Christopher, and Diebenkorn returned to CSFA as a faculty member.[14] The school was vital and experimental–in many ways it could be compared to Black Mountain College in North Carolina–and its atmosphere was one of intense exploration. The most serious problem to be grappled with was how to resolve the problems of figuration versus abstraction. John Hultberg, a student of Diebenkorn's remembered:

> Everyone talked about how to get abstraction and the image simultaneously. How to get the human element, comic in tragic, but also keep the religion of pure paint, how to get to the human but preserve the intensity of non-objective painting: Diebenkorn bridged both.[15]

The paintings of 1946-1947 were typified by figure-ground related forms, often only slightly abstracted from their sources: radar equipment, animals, electric light bulbs, sailboats, the anvil and wrench.[16] The paintings also referred to landscape.

> It was impossible to imagine doing a picture without it being a landscape; to try to make a painting space, a pure painting space, but always end up with a figure against a ground.[17]

In 1947 Jermayne MacAgy, director of the Legion, invited Diebenkorn, who was then only twenty-five, to exhibit there the following year. The work was typically thickly painted, opaque, the shapes carefully balanced against one another.

> His *Painting II,* 1949 reveals characteristics typical of the time: very thickly painted orange surfaces, coruscating dashes of pigment crackling (or sometimes cracking) through the surface in the manner of Clyfford Still, and a lateral stretching of form and textured surface toward the picture edges, with effects produced by painting wet-on-wet frequently encountered…[in] *Untitled,* 1949 one of the pictures in that exhibition, there is a new landscape light, a loose calligraphy with yellow streaked boldly, directly from the tube… Reminiscent of Rothko here is the mauve-black configuration of resting soft-edge square patches….[18]

Gerald Nordland wrote, some years later, of that exhibition:

> Judged by current standards, the Legion show was composed of small paintings. The paintings had a structural base which rested in Cubism and a division of the picture surface which took the form of abstract

geometry. Space tended towards flatness but there were passages handled three-dimensionally which created a tension between forward and backward in the picture space. One might say that the first generation of American abstract painters Dove and O'Keeffe—and a romantic sense of space and color were brought to the artist's impressive debut.[19]

In 1950 Diebenkorn decided to take advantage of the G.I. Bill to pursue his graduate studies at the University of Albuquerque in New Mexico. Various reasons have been put forth for Diebenkorn going to New Mexico—it would seem his fondness for the landscape was part of the decision. The paintings he made between 1950-1952 are referred to as the *Albuquerque* paintings,[20] and were clearer, softer, more rhythmical than his previous work. His use of both color and line (or calligraphy) reflect the greatest change. The landscape, the aerial views afforded by flights between California and New Mexico, the farm animals and the freedom to improvise—a "quality here that would have been impossible in San Francisco…[and] Diebenkorn's move out of the Bay Area at this time was necessary to allow him space to breathe."[21]

It took Diebenkorn only one year to qualify for his M.F.A. degree and his Masters Thesis exhibition. The paintings in that exhibition reflected the break he had made.

> The most important element is the discovered individuality which was suggested in the Palace Show of 1948 and had come to fulfillment in 1950-1951… There is little conventional fine handling or seductive surfaces in these works. They have a toughness as of the New Mexico desert. They are "right" but at the same time foreign and obviously subject only to their own rules.[22]

Diebenkorn said in the early 1950s: "I'm really a traditional painter, not avant-garde at all. I wanted to follow a tradition and extend it."[23] The paintings of both Matisse and Miró (as well as the influence of Hassel Smith) provided that tradition; Diebenkorn admired Matisse's sense of structure and color and was continually attracted to Miró's humor. There were also other untraditional interests. In writing about Diebenkorn's *Untitled*, 1950, Tuchman quotes the artist in the following passage:

> Diebenkorn consciously allowed a rather literal lamplike drawing and a humorous head shape associated with the comic strip character "Henry" to dominate: "objectness would occasionally pop up again so I would accept it and exaggerate it."… The artist's quirkily allusive line, his shorthand gesticulations filled with verve and humor can be traced in part to his affection for poetic cartoonist George Herriman's *Krazy Kat* comics, an anthology of which he bought in Albuquerque."[24]

It was during this productive time in New Mexico that Diebenkorn was visited by the Los Angeles collector and dealer, Paul Kantor, who purchased several paintings. Gerald Nordland and Dorothy Miller, Curator at The Museum of Modern Art also visited the studio and Motherwell included Diebenkorn, along with Hassel Smith and Edward Corbett, in his book *Modern Artists in America*.

The Diebenkorns stayed in Albuquerque through the spring of 1952 and returned to California that summer where, in Los Angeles, Diebenkorn saw the Matisse exhibition organized by Alfred H. Barr, Jr.[25] Invited to teach at the University of Illinois, Diebenkorn and his family moved to Champaign-Urbana in the fall of 1952. For a year, Diebenkorn taught drawing to architecture students. "At Urbana it is particularly difficult to find a key to his stylistic evolution," Tuchman has noted.[26] There are pictures which bear the title *Urbana*; however, as in Albuquerque and before, there are also paintings with other titles—even some which have since been retitled. The Urbana works are "intensely

colored"–partially because of the recent renewed contact with Matisse and also as a reaction against the bleakness of the midwestern landscape.[27] On the whole, the paintings of this group seem to recall earlier work and, as we can now see, anticipate the more complicated pictures to come. Writing of *Urbana No. 5*, 1953 (now titled *Beach Town*) Tuchman said:

> Elements in this picture can be traced back several years: The strong diagonal that runs left to center, implying middle to background, derives from Diebenkorn's appreciation of Cézanne's *Mont Sainte-Victoire*. Other sections are prophetic such as the blue and agitated green in the upper left-hand section which anticipate late landscapes. The graceful relatedness of small to large parts, curvilinear rhythms to straight edges, and the masterly interlocking of forms mark a new high point for the artist. In his use of diagonals, first introduced perhaps in a consistent way in this picture, Diebenkorn aims for a more complex and subtle sense of atmosphere without fear of losing abstractness.[28]

While in Urbana Diebenkorn had his first one-artist show at the Paul Kantor Gallery in Los Angeles. The paintings exhibited were from 1947-1952. One review read:

> ...devoid of seductive qualities, without clues other than what pigment or line imply Diebenkorn requires that the spectator propel himself into his activated surfaces. In [*Untitled*] *No. 3*, [1947], atmosphere is segmented by a wiry line that curls in on itself and thrusts across the canvas like a nerve imbedded in muscle tissue. In another oil titled *B*, 1952 [an Albuquerque painting, now titled *The Green Huntsman*] in blacks and whites, Diebenkorn conveys an impressive monumentality, not unlike the grandeur of desert mesas on a cold grey morning.[29]

The summer of 1953 was spent in New York City in a loft on East 12th Street. Aside from his friendship with Franz Kline, who at that time introduced him to the dealer Eleanor Poindexter, Diebenkorn did not find New York a pleasant or conducive atmosphere to live or work in.

> It was the environment in New York that put Diebenkorn off–the humidity, eating in automats; the fact that his car was broken into and art stolen from it–but most importantly, perhaps, it was the irregular pattern of New York artists that was inconducive to Diebenkorn's disciplined manner.[30]

The family returned to Berkeley in the fall and Diebenkorn took a teaching position at the California College of Arts and Crafts.

Diebenkorn began to paint the *Berkeley* paintings–a series which would occupy him for the next twenty months.

While he had been away, Bischoff and Park had begun to paint figuratively: Bischoff in 1952, Park in 1950-1951. Diebenkorn resumed his friendship with the two, becoming especially close to Park whom he described as:

> ...an astute, complex and educated man. He was my teacher at the California School of Fine Arts. He knew music and played jazz piano... He was paternal toward me and more than often he reverted to the role of teacher. He was born in 1911 and there was a consequent difference in our thinking. It was a rewarding relationship. David was committed to extreme painterliness and he related this to quality and to emotion.[31]

The influence of what he saw in New York—especially the work of de Kooning, Kline, Rothko—was combined in these paintings done between the fall of 1953 and the summer of 1955. While they reflect abstract expressionist concerns they also reflect Diebenkorn's vision.

> Diebenkorn opens up full throttle, as it were, and paints in his own lyrical and expansive way an inspired series of abstract expressionistic canvases of the first importance. If the earlier compositional formats had been predominantly triple-banded or horizontally centered, the Berkeley pictures focus on a heightened "situational" characteristic. The cuts which divide areas and allow each to develop its own particular sense are characterized by greatly heightened impulsiveness and improvisation. Such released dynamics, especially when diagonal movements are involved, impel Diebenkorn to "use all wiles to avoid too much recession." In the Berkeley pictures the effect "is of objects totally clear of a deep space behind them"—indeed the "space" is quite as palpable and as felt as the object.[32]

This quality of equalizing the object and its space would develop further in the still life paintings begun in 1955. Perhaps in anticipation of his future figurative pictures, Diebenkorn joined Bischoff, Lobdell and Park in weekly figure drawing sessions. Diebenkorn won an Abraham Rosenberg Fellowship in 1954 which was to sustain him, without teaching, for the next two years. He exhibited widely during 1954-1955. He first exhibited the Berkeley paintings in the San Francisco Museum, he had a second solo show at the Paul Kantor Gallery, he was selected by Director James Johnson Sweeney to be included in The Solomon R. Guggenheim Museum's *Younger American Painters*, and he contributed two paintings to the III São Paulo Bienal. His works were reviewed, in *Young Painters* (organized by the Congress for Cultural Freedom in Rome), as "unbeautiful but moving...difficult but authentic." [33]

By the summer of 1955 Diebenkorn began to experiment with small still lifes. He says,

> I came to mistrust my desire to explode the picture...at one time the common device of using the super-emotional to get in gear with a painting used to serve me for access to painting too, but I mistrust that now...[34] Something was missing in the process—I sensed an emptiness—as though I were a performer. I felt the need for an art that was more contemplative and possibly even in the nature of problem solving...[35] It was almost as though I could do too much, [in the last abstract paintings, about 1955] too easily. There was nothing hard to come up against. And suddenly the figure paintings furnished a lot of this.[36]

Diebenkorn's first still lifes depicted simple arrangements of objects—books, scissors, cups, glasses and silverware on table tops. These works introduced complicated compositional devices which would occupy Diebenkorn's work for the next several years. Nordland has written of the paintings:

> It must be noted that Diebenkorn's still life paintings tend to be seen at an angle to the table plane which is not traditional in Western painting. There is no accident in this abrupt angle of vision which often concentrates on the table to the omission of both foreground and background. One might conjecture a relationship with naive painting from this device but that is not the case. More properly one must relate it to the artist's observation of Persian and Indian miniature paintings, and to his knowledge of Matisse's famous masterpiece of 1911, *The Painter's Family*, which draws upon the Islamic tradition. It is, perhaps surprising that planar tilt has not been more fully discussed in Diebenkorn's work, for the seating of his still life objects in the picture space is made more complicated by the forced angle of the plane.[37]

Diebenkorn progressed from the small still life paintings to a larger format (nearly five feet square). Usually there was a single figure (occasionally two) and often a table with an arrangement of objects; mostly the figures were set in interiors which incorporated a window through which was seen a landscape or cityscape beyond. The paintings of this decade are rich in architectural elements – the planes, which make up the picture, meet and often overlap forming junctures of unusual colors. The figures are static, lonely, sometimes faceless or turned away from the observer. They are exciting pictures: *Figure on Porch,* 1959 and *Interior with View of the Ocean,* 1957 are among the finest and richest works. *Figure on Porch* depicts a single standing figure placed almost in the center of the canvas. The canvas is divided in horizontal bands – sky, sea, fields and porch. The structure and colors hark back to *Palo Alto Circle. Interior with View of the Ocean*, is bolder and the horizontal element is architectural rather than figurative. It separates two large windows; the foreground is divided by triangles of brilliant yellow light and dark purple and blue shadow. Nordland has written "...after 1955 the still life/landscape/figure paintings sought to use both the composition of visual elements as well as the psychological implications of the subject matter. This, in turn, gave him new perspective on the formal elements." [38]

For several months into his figurative explorations, Diebenkorn continued to exhibit only his earlier abstract work. The abstract work was highly regarded and Diebenkorn was already thought of as an important and influential painter. He, along with Clyfford Still, was asked in 1955 to exhibit in the opening exhibition of the Ferus Gallery in Los Angeles. This gallery was started by Edward Kienholtz with Irving Blum and Walter Hopps and was to be a showcase for some of the best art made in California. The opening show entitled *Objects in the New Landscape Demanding of the Eye* included John Altoon, Billy Al Bengston, Roy deForrest, Kienholtz and Craig Kauffman. Betty Turnbull explained the inclusion of Diebenkorn and Still:

> [It] was a kind of survey of western abstract expressionism that had been going on, particularly in the San Francisco Bay Area, during the late 40's and early 50's. To emphasize the importance of this movement (and win the attention of potential collectors who had yet to become involved in this new art) Clyfford Still (with an untitled 1948 picture) and Richard Diebenkorn (with *Albuquerque No. 3*, 1951) were included as special guests. [39]

In 1956 Diebenkorn exhibited *Berkeley* paintings in his first one-artist exhibition at Eleanor Poindexter's gallery in New York where he had been included in a group show the previous year. Diebenkorn also took time out that year to build a new studio behind his house in Berkeley. Finally in late 1956 he exhibited the first figurative canvases at The Oakland Art Museum. Paul Mills wrote in his catalogue essay for the *Contemporary Bay Area Figurative Painting* exhibition:

> An unresolved, paradoxical quality is not infrequent there, in my opinion. I asked him [Diebenkorn] particularly about a large figure painting similar in this aspect to other recent works. It had a kind of deliberate opposition of flat, painterly areas with no specific subject reference and figuratively handled objects existing in a kind of realistic space...Diebenkorn replied this effect was not undeliberate, that he sometimes did use incongruity as a means of keeping paintings unsolved and alive... [40]

While the paintings become more accomplished, there arose in those years the problem of how to deal critically with Diebenkorn's oeuvre. The shift from abstraction to figuration was greeted with delight by many critics and collectors. Some, however, in their haste to claim a new figurative movement or school, failed to grasp what others thought were Diebenkorn's real goals. Ellen Johnson, Curator of The Oberlin Museum (where Diebenkorn was exhibited in 1955)

wrote in 1958, "Diebenkorn has been welcomed like the Prodigal Son because of his new figurative compositions; he is nevertheless much the same kind of painter he was two years ago."

Comparing *Berkeley No. 42*, 1955 to *Woman by a Large Window*, 1957 she continued:

> ...the sensation of being 'in the painting' is transmitted directly to the observer through the size and style of the painting in Diebenkorn's as well as in Pollock's and many other contemporary artists' work... It is captivating this way of organizing the picture plane into large, relatively open areas interrupted by a greater concentration of activity, a spilling of shapes and color asymmetrically placed in one side of the picture... In these new figurative compositions he had not abjured his earlier style, just as he had not turned his back on nature in his abstractions. [41]

Diebenkorn was beginning to emerge as "the reigning chef d'école of Bay Area figurative painting...."[42] prompting Hilton Kramer to write:

> The place thus accorded Diebenkorn's still developing oeuvre is more perhaps a cultural than an artistic phenomenon; more, that is, the result of an effort by critics and museums and collectors to resolve the conflicting claims of contemporary styles into a harmonious and political whole than of any very precise insight into particular works of art or commitment to their underlying aesthetic principle...But like all such phenomena, it draws impetus nonetheless from a specific artistic accomplishment.
>
> In the case of Diebenkorn, the scenario of the accomplishment consists of two distinct phases...The first of these was an Abstract Expressionist style that evolved, without explicitly depicting, an imagery drawn from the broad, sunny, open, uncluttered landscape of Northern California as it was then – in the later forties and early fifties – being adjusted to pictorial ideas and painterly manners imported from New York. The second phase dates from 1955 when Diebenkorn joined Park and Elmer Bischoff in adopting an explicit representational imagery without modifying his basic manner of painting, which is no longer abstract in a strict sense, remained Abstract Expressionist in taste, physical deportment and overall aesthetic loyalty. In the pictures of this second phase Diebenkorn was an abstract painter who now painted figures and landscapes.[43]

Diebenkorn's notes from 1959 indicate that in the more advanced stages of his figurative work the problems of representation were no longer as simple as he had once thought:

> Later, it became much harder work. It is always difficult to say what you mean whether in words or in paint. I hope for an element of surprise – a break in the system, or the system I'm using at the time may do that for me and that will be enough. I am mistrustful of extra-painting allusions and would ordinarily end up painting them out. I suppose that I was worried because I feared that what I was doing had already been done...A premeditated scheme or system is out of the question. Search for a mutation in a sequence that is sensible, inevitable, perhaps predictable. One is enough. The mutation too is sensible and inevitable but it is so in violation of the system of forces that called it up....[44]

Diebenkorn's remarks indicate his struggle to formulate a painting method which would give him the freedom to investigate space and color without the danger of becoming systematized or unemotional. For the next five or six years Diebenkorn produced an extraordinary variety of still life interior and cityscape paintings.

In 1960 and 1961 Diebenkorn was honored with two major exhibitions. Sixty-six paintings dating from 1952-1960 were selected by Director Thomas W. Leavitt for a retrospective at the Pasadena Art Museum. In 1961 The Phillips Collection presented a survey of eighteen of Diebenkorn's paintings from 1958-1960. Gifford Phillips wrote in the introduction to the catalogue: [he] had developed a concern with *composition*, whereas most painters today are principally concerned with *space*.[45]

This statement echoes Diebenkorn's own remarks concerning the paintings of this period, "I would like the colors, their shapes and positions to be arrived at in response to and dictated by the condition of the total space at the time they are considered."[46]

In a lengthy article in *Artforum*, in 1963 James Monte also examined Diebenkorn's use of space.

> Diebenkorn's talent far outstrips all other West Coast Neo-Figurative Painters, taken singly or at their collective best...It is well to remember that for the last seven or eight years Diebenkorn has attempted nothing less than the consummate marriage of verifiable subject matter, tightly locked in Renaissance space, with the spontaneity and freedom of gesture learned from the abstract expressionist tradition. To accomplish his aim without impinging and finally decimating either the subject depicted or the wonderfully fluid sense of abstract space Diebenkorn has, is a major accomplishment....[47]

Gerald Nordland wrote on the occasion of The Phillips Collection survey:

> In the past five years the artist has become increasingly independent of the self-discoveries of Abstract Expressionism. He finds less need to dramatize his paintings or their subjects. He is more profoundly concerned with the evocation of feelings through an unobtrusive composition, a sometimes obvious subject matter and a growing capacity to invest visual experience with meaning. While the habits of years are not easily lost, there is less of Abstract Expressionist paint handling and more apparent concern for the necessities of the subject than before. As a result, Diebenkorn has transcended the various influences which to some extent survived in the early work and has created a new art which has grown entirely out of his own life experience. The synthesis of his Abstract Expressionist concept of the artist, his interest in a fresh figuration, and his responsiveness to the tradition received from Bonnard and Matisse provide his new foundation.[48]

Diebenkorn was invited in 1964 to go to Russia on a cultural exchange program. There he added to his already extensive knowledge of Matisse and upon his return painted *Recollections of a Visit to Leningrad*, 1965 and *Large Still Life*, 1966 perhaps reflecting what he saw in Matisse's *The Conversation*, 1909 and *Harmony in Red* 1908-1909.[49] Diebenkorn also spent that year as artist-in-residence at Stanford University where he made numerous drawings ultimately exhibited and later published in a book by the University. Of the Stanford show, Philip Leider wrote:

> It is not Diebenkorn's way to transform his own relationship to his subject matter. Instead of the flat, dull confrontation of stranger with stranger, he will seize upon a relationship between her arm and the wall behind, extend its characteristics to that between her blouse and the table, and find, in the patterns and complexities which his eye articulates a vitality sadly lacking in the real situation. He uses Abstract Expressionist knowledge "not" to reinforce his representational work, nor does he try to reconcile the two. He grows towards the purposeful employment of subject matter towards ends expressive of completely different concerns.[50]

Offered a teaching position at UCLA in 1967 Diebenkorn moved his home and studio to Santa Monica in Southern California. He took a studio in a section of the city called Ocean Park and began a series of paintings of the same name. These pictures are larger than any of his previous works–usually a little more than seven feet high and about six feet wide. Painted at the rate of about ten or twelve a year, Diebenkorn has just completed *Ocean Park No. 105*.[51] The vocabulary of the paintings recalls many sources: the obvious references to Matisse, Bonnard, the aerial views afforded by flying, his Marine training as a map maker.[52] These paintings like all of those Diebenkorn has painted to date could be called landscapes; they certainly refer in size, scale and color to his environment. They are made up of great veiled blocks of changing color; there is a drawing understructure over which the colors sit and often there is more painting done over the top of both layers. In the *Ocean Park* paintings the canvases are usually divided horizontally approximately three-quarters of the way up. There is often a strong vertical element which divides the canvas near the extreme right or left-hand side; sometimes this element sits at the very edge of the canvas as a border. The top quarter of the canvas is usually the most complex area–divided and subdivided by bands and wedges of buttressed color. The horizontal and vertical elements (which were figurative or architectural in the previous paintings) stabilize the central "windows" of color.

> The *Ocean Park* paintings depend crucially on the artist's ability to create an alliance–strike a balance– between structural concern and tonal, spatial illusion. Space is "negotiated" in John Russell's apt term by definition and re-definition of the relationship of the tonal field...The vestiges of figure/ground relationships remain in force though now the emphasis occurs in preserving the integrity of the surface, while wedding surface notation to spatial illusion within.[53]

The earliest *Ocean Park* pictures, for example *Ocean Park No. 7*, *No. 10*, and *No. 21* have a central receding space–which has often been likened to that found in Matisse's *The French Window*, 1914 and *The Piano Lesson*, 1916. *Ocean Park No. 14*, 1963 and *Ocean Park No. 43*, 1971 are reminiscent of the Leningrad inspired interior/exterior paintings with curved elements carving out the areas of color–a calligraphic device which can be traced back to the very early *Albuquerque*, *Urbana*, and *Berkeley* paintings. The "Y" shape and inverted "Y" shape found in *Black Table*, 1960 and *View from the Porch*, 1959 also occurs in *Ocean Park No. 27*, *No. 32* and others.

> he is...supremely proficient in controlling huge fields of subtly modulated, atmospheric color, allowing subterranean layers of textured underpaint to shine warmly through cool surfaces, or conversely, revealing the threat of icy shadow under an ardent exterior. In addition, Diebenkorn is one of those artists who has a knack for inspiring art-historical nostalgia. It is not merely that he unabashedly reflects the influences of Hopper, Still, de Kooning, Rothko, Mondrian and above all, Matisse, but that he is able through sheer recreative virtuosity to remind you of what once seemed so thrilling about the earlier phases of modernism that he evokes.[54]

As the series progresses, the canvases become clearer, more reductive, the colors softer, and the underdrawing and over painting more delicate.[55] The calm of their rich surfaces helps to display Diebenkorn's intelligent love for light and line; "the abstract paintings permit an all-over light which wasn't possible for me in the representational work."[56]

Diebenkorn's paintings have always been forthright, honestly and deliberately betraying the methods of their making.

> The artist's method of painting, sketching, directly on the surface, painting, correcting, refining, scraping out, reversing, painting again–results in a paint surface that is multilayered and matter-of-factly painted. The surface becomes rich with its own record of experience, permitting ghosts of earlier layers and linear experiments to emerge from its semi-transparent body.[57]

John Russell has written of the *Ocean Park* series: "These are compound worlds that Richard Diebenkorn sets before us...they are the record, full and true, of one man's negotiations with painting...."[58]

At any point in his explorations, Richard Diebenkorn might have chosen to stop his investigations, chosen to remain with what he knew would "work" and make good paintings. But instead he has never done this, he has never bored us with repetition, with painting whose nuance are their only justification. Diebenkorn constantly expands the limits of his work; he risks what he knows in order to make discoveries. Asked why he paints, he once replied:

> It is a great experience to violate my overall conception of what a picture has to be and find that in doing so, that it has changed me.[59]

Linda L. Cathcart

Acknowledgments

I would like to extend sincere appreciation to all those who helped realize this project: to Robert T. Buck, Jr. both as United States Commissioner of the Biennale and as Director of the Albright-Knox Art Gallery; Wilder Green, Director of The American Federation of Arts; Thomas Messer, Chairman of the International Exhibitions Committee. My own staff for this project included Laura Fleischmann, Research Assistant, Karen Spaulding, Editor, Serena Rattazzi, Coordinator of Public Relations; Norma Bardo, Curatorial Secretary, Annette Masling, Librarian and her Assistant, Margaret Cantrick. From The American Federation of Arts staff, I was assisted throughout by Melissa Meighan, Coordinator of the American section of the 1978 Venice Biennale and Registrar, Konrad G. Kuchel, Coordinator of Loans, Mary Ann Monet, Secretary, and Michael Shroyer, Graphic Designer. Thanks to the many galleries and museums who provided invaluable files and photographs, including M. Knoedler & Co. and Blum/Helman. Special appreciation to the lenders to this exhibition who have been extraordinarily generous and without whose good faith an exhibition such as this one could never be accomplished, and to Phyllis Diebenkorn for her unending patience and to Richard Diebenkorn for the wonderful paintings.

L.L.C.

This essay is an expanded version of "Reaction and Response," in *Richard Diebenkorn: Paintings and Drawings, 1943-1976*, Albright-Knox Art Gallery, Buffalo, 1976.

Notes

1. Maurice Tuchman, "Diebenkorn's Early Years," *Richard Diebenkorn: Paintings and Drawings, 1943-1976* (Albright-Knox Art Gallery, Buffalo, 1976) p. 5.

2. Ibid., p. 5.

3. Ibid., p. 6.

4. Ibid.

5. Ibid., p. 7.

6. Motherwell's *The Room* was the painting reproduced.

7. Frederick Wight, "The Phillips Collection – Diebenkorn, Woelffer, Mullican: A Discussion," *Artforum*, vol. 1, no. 10, Apr. 1963, p. 26.

8. Tuchman, "Diebenkorn's Early Years," p. 7.

9. Peter Plagens, *Sunshine Muse* (Praeger, New York, 1974) p. 36.

10. Tuchman, "Diebenkorn's Early Years," p. 10.

11. Ibid.

12. Ibid., p. 12.

13. Ibid., p. 7.

14. Douglas MacAgy had invited Diebenkorn to return as a faculty member before he left for Woodstock.

15. Tuchman, "Diebenkorn's Early Years," p. 8.

16. "The anvil and wrench can be traced to his vivid recollections of an ironsmith during boyhood summers with his grandmother at Woodside, California." Tuchman, "Diebenkorn's Early Years," p. 8.

17. Tuchman, "Diebenkorn's Early Years," p. 13.

18. Ibid.

19. Gerald Nordland, *Richard Diebenkorn* (Washington Gallery of Modern Art, Washington, D. C., 1964) p. 8.

20. Many of the paintings of this period are titled *Albuquerque*; many however have other names, *Miller 22, Untitled*, etc.

21. Tuchman, "Diebenkorn's Early Years," p. 14.

22. Nordland, *Richard Diebenkorn*, p. 10.

23. Tuchman, "Diebenkorn's Early Years," p. 13.

24. Ibid., p. 15.

25. Included in that exhibition were *The Red Studio, Goldfish, Goldfish and Sculpture, Woman on a High Stool, The Piano Lesson, The Moroccans* and *Tea.*

26. Tuchman, "Diebenkorn's Early Years," p. 18.

27. Ibid.

28. Ibid.

29. Jules Langsner, "Art News from Los Angeles: Diebenkorn and Randall," *Art News*, vol. 51, no. 7 (November 1952) p. 61.

30. Tuchman, "Diebenkorn's Early Years," p. 23.

31. Gerald Nordland, "The Figurative Works of Richard Diebenkorn," *Richard Diebenkorn: Paintings and Drawings, 1943-1976* (Albright-Knox Art Gallery, Buffalo, 1976) p. 26.

32. Tuchman, "Diebenkorn's Early Years," p. 23.

33. Dore Ashton, "Young Painters in Rome," *Arts Digest*, vol. 29, no. 17, (June 1955) p. 6.

34. Nordland, "The Figurative Works of Richard Diebenkorn," p. 26.

35. Diebenkorn quoted in Nordland, "The Figurative Works of Richard Diebenkorn," p. 26.

36. Gail R. Scott, *New Paintings by Richard Diebenkorn* (Los Angeles County Museum of Art, Los Angeles, 1969) p. 6.

37. Nordland, "The Figurative Works of Richard Diebenkorn," p. 27.

38. Nordland, *Richard Diebenkorn, The Ocean Park Series: Recent Work* (Marlborough Gallery, New York, 1971), p. 10.

39. Betty Turnbull, *The Last Time I Saw Ferus* (Newport Harbor Art Museum, Newport Beach, 1976) n.p.

40. Paul Mills, *Contemporary Bay Area Figurative Painters* (The Oakland Art Museum, Oakland, 1957) p. 12.

41. Ellen Johnson, "Diebenkorn's Woman by a Window," *(Allen Memorial Art Museum Bulletin, Oberlin College),* vol. 16, no. 1, Fall 1958., p. 19.

42. Hilton Kramer, "Pure and Impure Diebenkorn," *Arts Magazine*, vol. 62, no. 8, p. 47.

43. Ibid.

44. Diebenkorn, Studio notes, quoted in Nordland, "The Figurative Works of Richard Diebenkorn," pp. 34-35.

45. Gifford Phillips, *Richard Diebenkorn* (The Phillips Collection, Washington, D. C., 1961) n.p.

46. Nordland, "The Figurative Works of Richard Diebenkorn," p. 34.

47. J[ames] M[onte], "Reviews: Drawings by Elmer Bischoff, Richard Diebenkorn and Frank Lobdell, *Artforum*, vol. 2, no. 1, 1963, p. 7.

48. Nordland, "Richard Diebenkorn," *Artforum*, vol. 3, no. 4, Jan. 1965, p. 25.

49. Nordland, "The Figurative Works of Richard Diebenkorn," pp. 39-40.

50. Philip Leider, "Diebenkorn Drawings at Stanford," *Artforum*, vol. 2, no. 11, May 1964, p. 42.

51. Actually there are not exactly 105 paintings in existence; some have been destroyed, others repainted or renumbered.

52. Tuchman, "Diebenkorn's Early Years," p. 6.

53. Robert T. Buck, Jr., "The Ocean Park Paintings," *Richard Diebenkorn: Paintings and Drawings 1943-1976* (Albright-Knox Art Gallery, Buffalo, 1976) p. 46.

54. Nancy Marmer, "Richard Diebenkorn: Pacific Extensions," *Art in America*, vol. 66, no. 1, Jan.-Feb. 1978, p. 98.

55. Buck, "The Ocean Park Paintings," p. 46.

56. Nordland, *Richard Diebenkorn, The Ocean Park Series: Recent Work,* p. 11.

57. Ibid.

58. John Russell, *Richard Diebenkorn, The Ocean Park Series: Recent Work* (Marlborough Fine Art Ltd., London, 1973), p. 8.

59. Nordland, *Richard Diebenkorn, The Ocean Park Series: Recent Work*, p. 10.

Richard Diebenkorn

Si è presentata recentemente l'opportunità di esaminare con un certo agio l'opera di Richard Diebenkorn. Diebenkorn non è mai stato trascurato come pittore–ha cominciato ad esporre ancor prima di finire gli studi ed ha continuato a far mostre fin d'allora regolarmente. Le recensioni e gli scritti a proposito delle sue successive serie di quadri sono stati unanimemente positivi.

In occasione di questa mostra di dipinti dalla serie *Ocean Park,* ci è data di nuovo la possibilità di riflettere sulla carriera di questo eccezionale pittore.

Richard Clifford Diebenkorn Jr., figlio unico di Dorothy e Richard Diebenkorn, nacque a Portland, Oregon nel 1922. All'età di due anni si trasferì con la famiglia a San Francisco, che rimase la sua "base" fino al 1967, quando si stabilì a Santa Monica, dove tutt'ora vive e lavora. La nonna materna, Florence Stephens, molto vicina alla famiglia, era una donna eccezionale, con notevoli interessi in tutte le forme d'arte–poesia, pittura, letteratura–che incoraggiava costantemente il nipote a leggere molto durante le estati passate insieme. Più tardi la cuoca di casa lo avrebbe rifornito del materiale necessario per illustrare le avventure ispirate ai racconti che la nonna gli consigliava. Da adolescente, Diebenkorn non fu incoraggiato a dedicarsi all'arte nè dai genitori nè nell'ambiente del liceo sperimentale che frequentava: comunque continuava a disegnare a casa.

Iscritto alla Stanford University, nelle vicinanze di Palo Alto, e distolto dal padre dal perseguire una laurea in arte, Diebenkorn si dedicò a corsi di carattere generale. Ben presto incominciò ad interessarsi di musica, storia e letteratura, in particolar modo degli scritti di Faulkner, Hemingway e Sherwood Anderson e, al terzo anno, si iscrisse ad alcuni corsi d'arte. Daniel Mendelowitz e Victor Arnautoff furono suoi maestri per pittura a olio e acquarello. Furono loro a mostrare per primi a Diebenkorn, con diapositive e riproduzioni, l'opera di Arthur G. Dove, Edward Hopper, Reginald Marsh e Charles Sheeler. Essi lo incoraggiarono anche a lavorare sia in interni, che all'aria aperta. Mentre era a Stanford, Diebenkorn incontrò Phyllis Gilman, che sposò nel 1943. La maggior parte delle opere giovanili è andata perduta o è stata distrutta dall'artista; Diebenkorn così descrive il suo primo olio: "un paesaggio surrealista, squallido e semplice, con un cubo al posto del sole e della luna–un pò forzato".[1] Il primo dipinto giovanile tuttora esistente è un competente omaggio ad Edward Hopper. *Palo Alto Circle* 1943 è una piccola tela divisa orizzontalmente in tre parti: il cielo, un albergo e un primo piano che contiene una rotaia della ferrovia e un recinto Richiama l'uso della veduta tagliata, il forte contrasto di luce e ombra e la composizione statica di Hopper, ma è allo stresso tempo partecipe delle invenzioni proprie di Diebenkorn.

> Ci sono elementi personali che sono totalmente estranei al modo di vedere di Hopper, quali la coincidenza del bordo superiore del recinto in primo piano. Questo espediente, che fonde spazialmente piani separati in una superficie piatta, costituisce una notevole invenzione per un artista alle prime armi e lo sarebbe stata anche se Diebenkorn avesse conosciuto bene Cézanne a quell'epoca.[2]

Allo scoppio della guerra, durante l'estate del 1943, Diebenkorn si arruolò nei "Marines". L'autunno successivo i "Marines" lo iscrissero all'Università di California a Berkeley come studente di fisica e d'arte. I suoi insegnanti d'arte furono Worth Ryder, Eugene Neuhaus e Erle Loran. Loran era critico e pittore al tempo stesso ed era stato allievo di Hans Hofmann: egli aveva un'impostazione critica molto più intellettualistica dei precedenti maestri di Diebenkorn. Il senso critico e la continua introspezione di Loran aiutarono Diebenkorn ad acquistare indipendenza mentale di cui aveva bisogno per studiare e lavorare nei due anni successivi, passati sotto le armi nell'Est.

Dopo un periodo di addestramento, Diebenkorn fu inviato alla base dei Marines in Quantico, Virginia, vicino ad Washington, D.C., dove cominciò a dipingere di nuovo e a dipingere ritratti dei suoi commilitoni.[3] Andava

frequentemente a Washington, a visitare la Phillips Collection, che include, tra l'altro notevoli esemplari di Bonnard, Braque, Matisse e Picasso. Questa scoperta dei maestri europei aprì un'altra dimensione alla già ampia visione del giovane Diebenkorn, che fu particolarmente colpito da *The Studio, Quai St. Michel* 1916 di Matisse. L'uso da parte di Matisse di elementi architettonici in modo da definire e porre in relazione piani diversi del dipinto, lasciò un'impronta durevole su Diebenkorn.

> Questo contrasto, che permette al pittore di sottolineare la solidità dello spazio e l'evanescenza della luce, era molto congeniale a Diebenkorn, che più tardi fonderà non solo interni ed esterni, ma anche nature morte e paesaggi con elementi figurativi.[4]

Durante il suo soggiorno in Virginia, Diebenkorn visitò pure la Gallatin Collection del Philadelphia Museum of Art, dove vide lavori di Arp, Cézanne, Klee, Matisse e Mirò. Maurice Tuchman ha scritto che i collages di Arp con le loro forme biomorfiche, e le opere di Klee e Schwitters con le loro "suddivisioni spaziali" e "configurazioni bizzarre e quasi geometriche"[5] incuriosirono molto Diebenkorn.

Per quanto vivesse nell'Est, Diebenkorn non era abbastanza informato circa le varie attività degli artisti newyorkesi. Per caso vide alcune copie della rivista *DYN* sulle quali erano riprodotte opere di Motherwell[6] e Baziotes.

> Questi, nel momento in cui mi interessavo al modernismo francese, mi colpirono enormemente. Stranamente, erano ed al tempo stesso non era no correlati.[7]. Un'intera generazione era stata trascurata da Motherwell, per esempio Dove.[8]

Sia le opere di Baziotes che di Motherwell in questo periodo riecheggiavano il Surrealismo, mentre i quadri di Diebenkorn in questo periodo, anche se in qualche modo ispirati al Surrealismo, al tempo stesso riflettevano le strutture Cubiste che lui aveva rielaborato attraverso lo studio di Cézanne e Picasso.

Congedato dai Marines nel 1945, Diebenkorn ritornò a San Francisco, per studiare alla California School of Fine Arts (chiamata oggi San Francisco Art Institute). Direttore della scuola era l'energico Douglas MacAgy; membri della facoltà Elmer Bischoff, David Park e Hassel Smith; professori aggiunti: Al Reinhardt, Mark Rothko e Clyfford Still.

Diebenkorn non ebbe molti contatti con Clyfford Still, la cui personale al California Palace of the Legion of Honor nel 1947, ebbe un enorme impatto su molti artisti della *Bay area,* compreso Diebenkorn. Rothko, che era più vicino a Diebenkorn, insegnò per due sessioni estive nel 1948-49 al CSFA; era solito portare in classe: "…diapositive delle opere di Pollock, Robert Motherwell, Adolph Gottlieb, Willem de Kooning e altri"[9], e anche un originale Dubuffet per mostrare che "l'arte può far male".[10]

> Diebenkorn disse una volta a Gerald Nordland che valeva la pena di fare una visita al San Francisco Museum of Art "solo per vedere il quadro di Rothko: *Slow Swirl at the edge of the sea.* 1943"[1]

Al CSFA Diebenkorn ben presto guadagnò la stima e il rispetto degli studenti e dei professori e nel 1946 vinse una borsa di studio Albert Bender, concepita per facilitare i viaggi di studio degli studenti nell'Est. Nell'autunno di quell'anno Diebenkorn, con la moglie e la loro prima bambina Gretchen, si trasferì a Woodstock (New York), dove passò l'inverno, dipingendo incessantemente e con grande impegno. Conobbe artisti che vivevano in quella zona, come Bradley Walker Tomlin, Baziotes e Raoul Hague ed, a New York, Franz Kline. Visitò la Galleria di avanguardia

Kootz e frequentemente il Museum of Modern Art. Dietro suggerimento di David Park, si era documentato su Mirò ed al Museum of Modern Art aveva visto *Person throwing a stone at a bird* del 1927. In seguito Diebenkorn userà lettere tipo-Mirò, frecce od altri simboli bizzarri nel suo lavoro; era tuttavia spesso in dubbio circa questo aspetto del suo lavoro. Una volta ammise:

> Pensavo di essere un puro non-figurativo – e rovinavo un così gran numero di tele perchè vi trovavo un frammento rappresentativo, un qualsiasi Topolino…e via, tornavo a rifare tutto da capo.[12]

Ma, la cosa più importante, come ha notato Tuchman, fu lo studio della composizione e dei colori di Mirò.

> Da Mirò aveva appreso a curvare un'ampia forma, a darle un aspetto bizzaro ed evocativo; la sensazione che le forme sono tirate fino al punto di rottura nell'opera di Diebenkorn deriva da Mirò. Tuttavia, in primo luogo, fu il colore di Mirò – "con il suo peso, la sua opacità e contenutezza" – ad allargare permanentemente il vocabolario pittorico di Diebenkorn.[13]

I Diebenkorn lasciarono Woodstock nella primavera del 1947 col loro secondo figlio Cristopher e Diebenkorn ritornò a CSFA come membro della facoltà.[14] La scuola era molto attiva e sperimentale – sotto alcuni aspetti si poteva paragonare al Black Mountain College della North Caroline – con un'atmosfera di continua scoperta. Il problema più pressante da risolvere era quello della "figurazione" rispetto all'astrattismo. John Hultberg, uno studente di Diebenkorn ricorda:

> Tutti dibattevano il problema di come ottenere astrazione ed immagine allo stesso tempo. Come inserire l'elemento umano, l'elemento comico nella tragedia, mantenendo l'impegno della pura pittura; come raggiungere l'elemento umano, preservando l'intensità della pittura astratta: Diebenkorn lo ha ottenuto.[15]

Le opere degli anni 1946-47 erano caratterizzate da forme viste nella relazione figura/sfondo, spesso solo leggermente astratte dalle loro fonti: equipaggiamento radar, animali, lampadine elettriche, barche a vela, incudini e chiavi inglesi.[16] I dipinti facevano riferimento anche al paesaggio.

> Era inconcepibile di dipingere un quadro senza che fosse un paesaggio: di rendere una pittura "spazio," puro spazio pittorico: si finiva sempre con una figura contro lo sfondo.

Nel 1947 Jermayne McAgy, direttrice del California Palace of the Legion of Honor invitò Diebenkorn appena venticinquenne, ad esporre nell'anno successivo. I suoi quadri erano allora tipicamente opachi, di spesso impasto, le forme prudentemente bilanciate l'una rispetto all'altra.

> Il suo *Painting II,* 1949 rivela caratteristiche tipiche dell'epoca: superfici dipinte in uno spesso strato arancione, pennellate scintillanti di pigmento che si screpola alla superficie, alla maniera di Clyfford Still, una tensione laterale della forma, un movimentarsi della superficie verso gli orli della pittura, con frequenti effetti dovuti al sovrapporre nuovo colore sullo sfondo ancora fresco. Nel: *Untitled* 1949, una delle opere esposte in quella mostra, esiste una nuova luce del paesaggio, una disinvolta calligrafia col giallo applicato spavaldamente dal tubo…. Memore di Rothko è qui la configurazione malva-nera degli scomparti quadrati dal bordo impreciso…[18]

Gerald Nordland scrisse qualche anno dopo, a proposito di tale mostra:

> In base agli standard correnti, la mostra alla Legion era composta di quadri piccoli. Le opere avevano una base strutturale derivata dal Cubismo ed una suddivisione della superficie pittorica che assumeva una forma geometrico–astratta. Lo spazio tendeva alla piattezza, ma c'erano passaggi trattati tridimensionalmente che creavano una tensione bi-direzionle nello spazio pittorico. Si può dire che la prima generazione di pittori americani astratti, Dove e O'Keeffe–e un romantico senso di spazio e colore venivano traslati nello straordinario debutto dell'artista.[19]

Nel 1950 Diebenkorn decise di approfittare del G.I. Bill (legislazione che permetteva agli ex militari della II guerra mondiale di riprendere gli studi interrotti, gratuitamente) per completare i suoi studi all'Università di Albuquerque, in New Mexico.

C'erano varie ragioni per il trasferimento di Diebenkorn in New Mexico–un fattore importante in questa decisione era probabilmente il suo amore per quel paesaggio. Le opere dipinte tra il 1950-52 sono designate come i dipinti di *Albuquerque*[20] ed erano più chiari, più dolci e ritmici del lavoro precedente. Sia il colore che la linea (o calligrafia) riflettono un cambiamento dei più notevoli. Il paesaggio, la veduta aerea permessa dai voli tra la California e il New Mexico, gli animali nelle fattorie, la libertà di improvvisazione–"possibilità che sarebbe stata irrealizzabile a San Francisco...", e il trasferimento di Diebenkorn fuori dalla Bay Area in questo momento erano fattori indispensabili per permettergli un più ampio respiro".[21]

In un anno Diebenkorn consegnì la laurea in belle arti (Master of Fine Arts) la cui tesi consisteva, come di consueto, in una mostra. Le opere esposte riflettevano la rottura che si era prodotta nella sua opera.

> L'elemento più importante è la scoperta della propria individualità, già suggerita nel "Palace Show" del 1948 e che era venuta a maturazione nel 1950-51.... Esiste poco del raffinato trattamento o superfici seducenti in questi lavori. Mostrano una durezza da deserto del New Mexico. Sono opere "giuste", ma al tempo stesso estranee e ovviamente soggette soltanto a loro regole particolari.[22]

Diebenkorn aveva detto verso il '50: "Io sono in realtà un pittore tradizionale, per niente di avanguardia. Volevo seguire una tradizione ed allargarla".[23] Le opere sia di Matisse che di Mirò (come l'influsso di Hassel Smith) fornivano gli elementi di quella tradizione; Diebenkorn ammirava la struttura ed il colore di Matisse ed era costantemente attratto dallo spirito di Mirò. C'erano anche altri interessi di natura non tradizionale. Tuchman, scrivendo a proposito dell'opera di Diebenkorn *Untitled* del 1950, cita l'artista nel seguente brano:

> Diebenkorn coscientemente ha lasciato che un disegno abbastanza letterale di una specie di lampada ed una buffa forma di testa ispirata al personaggio dei fumetti "Henry" dominassero il campo: "l'essenza dell'oggetto ogni tanto viene a galla di nuovo, così io l'accetto e l'esagero." La linea dell'artista, erraticamente allusiva, i suoi gesti stenografici pieni di verve e di spirito si possono attribuire in parte al suo debole per i poetici fumetti *Krazy Kat,* di George Herriman, dei quali aveva comprato un'antologia ad Albuquerque.[24]

Fu durante questo fecondo periodo in New Mexico che Diebenkorn ricevette la visita del collezionista e mercante d'arte Paul Kantor, che gli acquistò diversi quadri. Visitarono il suo studio anche Gerald Nordland e Dorothy Miller, conservatrice del Museum of Modern Art; e Motherwell lo incluse insieme ad altri artisti, quali Hassel Smith e Edward Corbett nel suo libro: *Modern Artists in America.*

I Diebenkorn rimasero ad Albuquerque per tutta la primavera del 1952 e nell'estate ritornarono in California, dove, a Los Angeles, Diebenkorn vide la mostra di Matisse organizzata da Alfred H. Barr Jr.[25] Invitato ad insegnare all'Università dell'Illinois, Diebenkorn si trasferì con la famiglia a Champaign-Urbana nell'autunno del 1952. Per un anno, Diebenkorn insegnò elementi di disegno agli studenti di architettura. "E molto difficile trovare una chiave alla sua evoluzione stilistica a Urbana", ha notato Tuchman.[26] Ci sono alcuni quadri col titolo *Urbana*; tuttavia, come in Albuquerque e prima di quel periodo, ci sono anche dipinti con diversi titoli, e altri che da allora hanno perfino assunto un nuovo titolo. I dipinti di Urbana sono "intensamente colorati" il che è dovuto in parte al recente rinnovato incontro con Matisse, in parte alla reazione contro la desolazione del paesaggio del Mid-West,[27] Nell'insieme le opere di questo gruppo si avvicinano a lavori precedenti e sembrano precorrere opere a venire, assai più complesse. A proposito di *Urbana n. 5*, 1953 (ora intitolata *Beach Town*) Tuchman scrive:

> Vi sono elementi in quest'opera che ricorrono a molti anni prima: La decisa diagonale a sinistra che pone in rapporto il centro allo sfondo, deriva dallo studio da parte di Diebenkorn del *Mont Sainte Victoire* di Cézanne. Altri dettagli precorrono opere future, come il blu e il tumultuoso verde nel riquadro in alto a sinistra che anticipano paesaggi a venire. Il delicato rapporto tra parti piccole e grandi, tra ritmi curvilinei e tagli lineari, e la superba sintesi di forme segnano una nuova vittoria per l'artista. Nell'uso delle diagonali, introdotto forse per la prima volta in modo logico in quest'opera, Diebenkorn tende ad un più complesso e sottile senso di atmosfera, senza il timore di venir meno all'astrazione.[28]

Mentre era ad Urbana, Diebenkorn fece la sua prima personale alla Galleria Paul Kantor di Los Angeles. Le opere esposte erano datate dal 1947 al 1952. Così una recensione:

> ...privo di qualità allettanti, senza altri suggerimenti che quelli del colore e della linea, è come se Diebenkorn richiedesse che lo spettatore si cali entro la superficie mossa del quadro. Nel (Untitled) *No. 3* (1947) la scena è segmentata da una linea serpentina che si ripiega su se stessa e attraversa la tela come un nervo inserito nel tessuto muscolare. In un altro olio intitolato *B 1952* (un dipinto di Albuquerque, oggi intitolato *The Green Huntsman*) Diebenkorn esprime nei bianchi e neri un'impressionante monumentalità, non dissimile dalla grandezza degli altipiani del deserto in una fredda grigia mattinata.[29]

Diebenkorn passò l'estate del 1953 a New York, in un grande studio sulla 12a strada nell 'East Side. A parte la sua amicizia con Franz Kline, che lo presentò alla gallerista Eleanor Poindexter, Diebenkorn non trovò l'atmosfera di New York nè piacevole, nè eccitante per viverci o lavorarci.

> Era l'ambiente a New York che scoraggiava e disincantava Diebenkorn—l'umidità, il mangiare in ristoranti automatici; il fatto che la sua macchina fosse stata forzata e ne fossero stati asportati dei quadri, ma più che altro, probabilmente era l'atteggiamento sregolato degli artisti newyorkesi che non era consono alla disciplina di Diebenkorn.[30]

I Diebenkorn ritornarono in California, a Berkeley, nell'autunno e Diebenkorn assunse un incarico di insegnamento al California College of Arts and Crafts.

Diebenkorn iniziò a dipingere la serie dei dipinti di *Berkeley*—serie che lo avrebbe tenuto impegnato per circa venti mesi.

Durante la sua assenza, Bischoff e Park avevano iniziato a dipingere figurativamente: Bischoff nel 1952, Park nel 1950-51. Diebenkorn riallacciò l'amicizia con loro, specialmente con Park, che così descriveva:

...un uomo sagace, complesso e colto. Era stato mio maestro alla California School of Fine Arts. Si interessava di musica e suonava musica jazz al pianoforte. Era molto paterno nei miei confronti, e molto spesso ritornava nel suo atteggiamento al ruolo di insegnante. Era nato nel 1911, e c'era una notevole differenza nel nostro modo di pensare. Era una relazione estremamente vantaggiosa per entrambi. David era impegnato a dare ai suoi quadri un'estrema pittoricità che egli metteva in rapporto con qualità ed emozioni.[31]

L'influenza di quanto Diebenkorn aveva visto a New York–specialmente l'opera di de Kooning, Kline e Rothko–era presente in questi dipinti eseguiti tra l'autunno del 1953 e l'estate del 1955. Essi riflettono motivi espressionisti-astratti e al tempo stesso la visione paesaggistica personale di Diebenkorn.

Diebenkorn si butta a capofitto, per così dire, e dipinge nel suo stile lirico ed aperto una serie di tele espressioniste–astratte di primissimo ordine. Se la composizione delle sue opere giovanili era stata prevalentemente a tripla banda o centrata in orizzontale, le opere di Berkeley si concentrano su una caratteristica "contingente" altamente stressata. I tagli che dividono le zone e lasciano che ognuna di esse si evolva individualmente, sono tracciati di getto e con grande improvvisazione. Tale dinamica lasciata esplodere, specialmente quando si tratta di movimenti diagonali, costringe Diebenkorn "ad usare tutti gli espedienti per evitare un'eccessiva retrocessione". Nelle opere di Berkeley l'effetto "è di oggetti assolutamente staccati dallo spazio restrostante"–in effetti lo "spazio" è sentito e tangibile tanto quanto l'oggetto.[32]

Questa caratteristica di dare lo stesso valore all' oggetto e al suo spazio si svilupperà ulteriormente nelle nature morte iniziate nel 1955. Probabilmente anticipando la sua futura pittura figurativa, Diebenkorn, con Bischoff, Lobdell e Park, prese parte a sessioni settimanali di disegno anatomico. Nel 1954 Diebenkorn vinse una Borsa Abraham Rosenberg che lo avrebbe praticamente mantenuto nei successivi due anni, senza insegnare. Fece molte mostre durante il 1954-55. Dapprima espose le opere di Berkeley nel Museo di San Francisco, ebbe una seconda personale alla Paul Kantor Gallery, fu scelto dal Direttore del Solomon R. Guggenheim Museum per essere incluso nella mostra *Younger American Painters* ed espose due opere alla III Biennale di San Paolo. Le sue opere nella mostra *Young Painters* (organizzata dal Congresso per la Libertà culturale a Roma) vennero recensite come: "non belle, ma commoventi...difficili, ma autentiche".[33]

Nell'estate del 1955 Diebenkorn iniziò a fare esperimenti con nature morte di piccolo formato. Così scrive:

Finii col diffidare del mio desiderio di far esplodere il quadro...un tempo l'espediente assai comune di usare l'eccesso di emozione per sincronizzarmi con un'opera mi serviva di accesso all'opera stessa, ma adesso ne diffido...[34] Si perdeva qualcosa nel processo–sentivo un senso di vuoto–come se fossi un attore. Sentivo il bisogno di un'arte che fosse più contemplativa, che possibilmente risolvesse dei problemi...[35] Era quasi come se potessi fare troppo, [negli ultimi dipinti astratti del 1955], troppo facilmente. Non c'erano difficoltà da superare. E d'un tratto i dipinti di figure mi creavano ampie difficoltà.[36]

Le prime nature morte di Diebenkorn rappresentavano semplici gruppi di oggetti–libri, forbici, tazze, bicchieri e posate su tavoli. Questi lavori introducevano espedienti compositivi assai complicati che avrebbero riempito l'opera di Diebenkorn per alcuni anni. Nordland scrive al proposito:

Si deve notare che le nature morte di Diebenkorn tendono ad essere viste ad un'angolatura rispetto al piano del tavolo che non è tradizionale nella pittura occidentale. Non è fortuita questa decisa angolatura visiva

che spesso si concentra sul tavolo, omettendo sia lo sfondo che il primo piano. Si potrebbe pensare ad un rapporto con la pittura naif a causa di questo espediente, ma non è il caso. Più propriamente ci si deve riferire allo studio da parte dell'artista di miniature Persiane e Indiane, ed alla sua conoscenza della famosa opera di Matisse del 1911, *The Painter's Family,* che si ispira alla tradizione islamica. Appare abbastanza sorprendente che l'inclinazione del piano nel lavoro di Diebenkorn non sia stata esaminata più a fondo, dal momento che la posizione degli oggetti nello spazio delle sue nature morte è resa molto più complicata proprio a causa dell'angolatura forzata del piano.[37]

Diebenkorn passò da piccoli dipinti di nature morte a formati più grandi (quasi di un metro e mezzo). Di solito c'era nel quadro una sola figura (qualche volta due) e spesso un tavolo con un vario accostamento di oggetti; nella maggior parte dei casi le figure erano disposte in un interno con una finestra, attraverso la quale si intravedeva un paesaggio o il profilo di una città. I dipinti di questo decennio sono ricchi di elementi architettonici–i piani che compongono l'opera si incontrano e spesso si sovrappongono, formando congiunzioni di colore inusitato. Le figure sono statiche, isolate, a volte senza viso, o con le spalle allo spettatore. Sono opere interessantissime: *Figure on Porch,* 1959 e *Interior with a View of the Ocean,* 1957 sono tra i suoi quadri migliori, più ricchi. *Figure on Porch* rappresenta una singola figura in piedi disposta quasi al centro del quadro. Il quadro è diviso in strisce orizzontali–cielo, mare, campi e portico. La struttura e i colori riecheggiano *Palo Alto Circle. Interior with View of the Ocean* è un'opera più audace e l'andamento orizzontale ha un valore più architettonico che figurativo. Un elemento separa due grandi finestre: il primo piano è diviso in triangoli di luce di un giallo squillante, e ombra viola scuro e blu. Nordland ha scritto:

> …dopo il 1955 i dipinti di nature morte-paesaggio-figura cercavano si adottare sia elementi compositivi di natura visiva che implicazioni psicologiche. Questo, a sua volta, gli dette una nuova prospettiva degli elementi formali.[38]

Per diversi mesi, Diebenkorn, seppure impegnato nella sua esplorazione del figurativo, continuò ad esporre solo le sue opere astratte. Queste erano molto quotate e Diebenkorn era già considerato un pittore di grande peso e influenza. Nel 1955 gli fu richiesto di esporre insieme a Clyfford Still nella mostra di apertura della Ferus Gallery a Los Angeles. Questa galleria era stata aperta da Edward Kienholtz, Irving Blum e Walter Hopps e sarebbe divenuta la vetrina espositiva delle opere d'arte più interessanti prodotte in California. La mostra di apertura intitolata: *Objects in the New Landscape Demanding of the Eye* includeva John Altoon, Billy Al Bengston, Roy de Forrest, Kienholtz e Craig Kauffman. Betty Turnbull così spiega l'inclusione di Diebenkorn e Still:

> …vi era una specie di revisione dell'espressionismo astratto occidentale, soprattutto nella San Francisco Bay Area, durante il decennio del '40 e i primi anni '50. Per dare un maggior rilievo a questo movimento (ed al tempo stesso accattivare l'interesse di futuri collezionisti), furono inclusi come ospiti speciali Clyfford Still (con un quadro senza titolo del 1948) e Richard Diebenkorn (con *Albuquerque n. 3* del 1951).[39]

Nel 1956 Diebenkorn espose la serie dei dipinti di *Berkeley* nella sua prima personale alla Galleria Eleanor Poindexter a New York, dove già aveva esposto in una collettiva l'anno precedente. Diebenkorn trovò anche il tempo in quell'anno di costruirsi uno studio dietro la casa, a Berkeley. Alla fine del 1956 espose le prime opere figurative al Oakland Art Museum. Paul Mills scrisse nell'occasione della mostra: *Contemporary Bay Area Figurative Painting:*

> A mio modo di vedere, esiste qui una qualità paradossale e non risolta. Gli chiesi (a Diebenkorn) di un grande dipinto a figure simile ad altri suoi lavori recenti. Presentava una voluta contrapposizione di zone piatte e pittoriche, di soggetto non determinato e oggetti trattati figurativamente in uno spazio in qualche

FERNALD LIBRARY
COLBY-SAWYER COLLEGE
NEW LONDON, N.H. 03257

modo realistico...Diebenkorn rispose che questo effetto era voluto e che a volte lui usava deliberatamente incongruenze come mezzo per mantenere il dipinto non risolto e vivo...[40]

Mentre i suoi dipinti divenivano più completi, sorgeva in quegli anni il problema di come discutere criticamente la sua opera. Il passaggio dall'astrazione al figurativo fu accolto con gioia da molti critici e collezionisti. Alcuni tuttavia, nella fretta di proclamare una nuova scuola o movimento figurativi, non afferrarono quelli che, secondo altri, erano i fini reali dell'opera di Diebenkorn. Ellen Johnson, conservatrice dell'Oberlin Museum (dove Diebenkorn aveva esposto nel 1955) scrisse nel 1958: "Diebenkorn è stato salutato come il Figliuol Prodigo per le sue nuove composizioni figurative: in realtà è più o meno lo stesso pittore di due anni fa."

Paragonando *Berkeley no. 42,* 1955 con *Woman by a Large Window,* 1957, continua:

> ...l'impressione di essere dentro il quadro' è trasmessa direttamente all'osservatore dalla grandezza e dallo stile del quadro in Diebenkorn, così come in Pollock e in molti altri artisti contemporanei.... Accattivante è questo modo di organizzare la superficie del quadro in spazi ampi, relativamente aperti, interrotti da un flusso di attività, un riversarsi di forme e colori disposti asimmetricamente da un lato del quadro.... In queste nuove composizioni figurative non è venuto meno allo stile dei suoi lavori precedenti, allo stesso modo che non aveva rinnegato la natura nelle sue astrazioni.[41]

Diebenkorn cominciava ad emergere come "il caposcuola della pittura figurativa della Bay area...."[42], inducendo Hilton Kramer a scrivere:

> La posizione concessa all'opera di Diebenkorn, che è ancora in fase di sviluppo, è un fenomeno forse più culturale che artistico; come a dire, il risultato di uno sforzo da parte di critici, musei e collezionisti di risolvere le esigenze contradditorie degli stili contemporanei in un insieme armonico e politico, più che una vera e propria comprensione a fondo delle singole opere d'arte o un impegno verso i loro fondamentali principi estetici.... Ma come accade in analoghi fenomeni, l'impulso tuttavia è dato da uno specifico successo artistico. Nel caso di Diebenkorn la trama del suo successo consiste di due fasi distinte.... La prima fu uno stile Astratto-Espressionista che sviluppò, senza dipingerle esplicitamente, immagini tratte dall'ampio, soleggiato, aperto e semplice paesaggio della California del Nord, com'era allora–negli ultimi anni del '40, i primi del '50–riveduto secondo i manierismi pittorici e le idee importati da New York. La seconda fase data dal 1955, quando Diebenkorn si associò a Park e Elmer Bischoff nell'adottare una visione rappresentativa esplicita senza modificare la sua fondamentale maniera di dipingere, che non più astratta, a rigore di termini, rimase Astratto–Espressionistica in gusto, apparenza fisica e fedeltà ai principi estetici d'insieme. Nei quadri di questa seconda fase Diebenkorn era tuttora un pittore astratto che dipingeva figure e paesaggi.[43]

Negli appunti di Diebenkorn dal 1959 appare evidente che, nelle fasi più avanzate della sua opera figurativa, il problema della rappresentazione non è più così semplice come egli aveva pensato originalmente:

> In seguito il lavoro divenne molto più difficile. E sempre difficile esprimere in parole o in pittura quello che si vuol dire. Spero in un elemento di sorpresa–una rottura nel sistema, o almeno nel sistema che io sto usando in quel momento, può provvedere una tale sorpresa e ciò sarebbe sufficiente per me. Io diffido delle allusioni da ricercarsi al di fuori del dipinto e finisco in genere per tralasciarle. Suppongo che fossi preoccupato che quello che stavo facendo, fosse già stato fatto.... Un sistema premeditato o semplicemente

un sistema è fuori discussione. E la ricerca di un mutamento in una sequenza che è razionale, inevitabile e forse prevedibile. Ne basta uno. Anche il mutamento è razionale e inevitabile, ma lo è contro il sistema di forze che lo hanno richiesto.[44]

Le osservazioni di Diebenkorn indicano il suo sforzo di di formulare un metodo di pittura che gli dia la libertà di indagare sullo spazio e colore senza il pericolo di divenire eccessivamente strutturato o freddo. Nei cinque o sei anni successivi, Diebenkorn produsse una straordinaria varietà di interni-nature morte e vedute di città.

Nel 1960 e 1961 vi furono due importanti mostre di Diebenkorn. Thomas W. Leavitt, Direttore del Pasadena Art Museum, scelse sessantasei quadri di Diebenkorn datati tra il 1950 e il 1960 per una retrospettiva al Museo.

Nel 1961 la Phillips Collection presentò una rassegna di diciotto opere di Diebenkorn dal 1958 al 1960. Gifford Phillips, nell' introduzione al catalogo, scrive: "mentre la maggior parte dei pittori oggi si preoccupa sopratutto dello *spazio*, egli si preoccupa della *composizione*."[45]

Questo giudizio rieccheggia le osservazioni di Diebenkorn circa i dipinti di questo periodo "vorrei arrivare ai colori, le loro forme e posizioni, in base alla condizione dello spazio complessivo al momento in cui tali elementi vengono presi in considerazione".[46]

Anche James Monte, in un lungo articolo in "Artforum" nel 1963, ha preso in esame l'uso che Diebenkorn fa dello spazio:

> Il talento di Diebenkorn ha di gran lunga superato quello di tutti gli altri pittori neo-figurativi della costa occidentale, presi sia singolarmente che collettivamente nel loro momento migliore... E bene ricordare che sono sette od otto anni che Diebenkorn tenta niente meno che di maritare un soggetto riconoscibile, strettamente bloccato in uno spazio rinascimentale, con la spontaneità e la libertà del gesto derivato dalla tradizione astratto-espressionista. Raggiungere questo scopo senza violentare e alla fine distruggere nè il soggetto prescelto nè il meraviglioso senso fluido dello spazio astratto che Diebenkorn ha, è veramente un importante risultato...[47]

In occasione della rassegna alla Phillips Collection, Gerald Nordland scrisse:

> Negli ultimi cinque anni l'artista è diventato sempre più indipendente dalle scoperte personali dell'Espressionismo Astratto. Sente meno il bisogno di drammatizzare i suoi quadri o il loro soggetto. Si preoccupa più profondamente di evocare sentimenti per mezzo di una composizione discreta, un soggetto talvolta ovvio e una crescente capacità di investire di significato l'esperienza visiva. Mentre non si perde facilmente l'abitudine di anni, c'è un modo meno astratto-espressionista di usare il colore e una preoccupazione più evidente di prima per le necessità del soggetto. Come risultato, Diebenkorn ha trasceso le varie influenze che fino a un certo grado sopravvivevano nelle sue prime opere e ha creato un'arte nuova che è interamente derivata dalla sua propria esperienza di vita. La sintesi tra il suo concetto di espressionismo astratto, il suo interesse in una nuova figurazione e la sua sensibilizzazione alla tradizione acquisita da Bonnard e Matisse, è alla base del suo nuovo lavoro.[48]

Nel 1964 Diebenkorn fu invitato ad andare in Russia per un programma di scambi culturali. Accrebbe là la sua già vasta conoscenza di Matisse e al suo ritorno dipinse *Recollection of a Visit to Leningrad*, 1965 e *Large Still Life*, 1966, che

riflettono forse quanto egli vide in *The Conversation*, 1909 e *Harmony in red*, 1908-1909 di Matisse.[49] Diebenkorn passò inoltre quell'anno come artista-residente alla Stanford University dove fece numerosi disegni esposti più tardi e pubblicati in un libro dall'Università. Sulla mostra di Stanford così scrisse Philip Leider:

> Non è nello stile di Diebenkorn di trasformare il suo rapporto con il soggetto trattato. Invece di una piatta e monotona contrapposizione di elementi estranei, egli coglie un rapporto tra il braccio di lei e la parete dietro, estende queste caratteristiche alla blusa e al tavolo e, nei motivi e nei complessi elementi che vede, trova una vitalità tristemente mancante nella situazione reale. Usa la sua conoscenza dell'Espressionismo Astratto per "non" rafforzare la sua opera rappresentativa, nè cerca di riconciliare i due. Egli volge man mano l'impiego intenzionale del soggetto a fini che siano espressione di preoccupazioni completamente diverse.[50]

Essendogli stato offerto un posto all'UCLA, nel 1967 Diebenkorn si trasferì a Santa Monica, nella California del sud. Egli prese uno studio in una parte della città chiamata Ocean Park e cominciò una serie di quadri dello stesso nome. Sono più grandi di qualsiasi altro lavoro precedente – di solito poco più di due metri di altezza e 1 metro e 80 di larghezza. Dipingendo al ritmo di 10 o 12 quadri all'anno, Diebenkorn ha appena completato *Ocean Park No. 105*.[51]

Il vocabolario dei quadri richiama alla mente molte fonti: ovvi riferimenti a Matisse, Bonnard, la vedute aeree rese possibili dal volo, il suo addestramento come cartografo quando era nei Marines.[52] Questi quadri, come tutti quelli che Diebenkorn ha dipinto finora, si possono chiamare paesaggi; per dimensione, scala e colore si riferiscono certamente all'ambiente che lo circonda. Sono formati da grandi zone velate di mutevole colore; c'è una sotto–struttura di disegno su cui sono posati i colori e spesso c'è ancora della pittura sopra i due strati. Nei quadri di *Ocean Park* le tele sono di solito divise orizzontalmente, a tre quarti circa dal basso. C'è spesso un forte elemento verticale che divide le tele alla estrema destra o all'estrema sinistra – talvolta questo elemento sta proprio come un bordo all'estremo lembo della tela. Il quarto superiore delle tela è di solito l'area più complesa – divisa e suddivisa da strisce e cunei di colore sostenuto. Gli elementi orizzontali e verticali (che nei quadri precedenti erano elementi figurativi o architettonici) stabilizzano le "finestre" centrali di colore.

> I quadri di *Ocean Park* dipendono in modo cruciale dall'abilità dell'artista di creare un legame, un equilibrio tra un problema di struttura e una illusione tonale e spaziale. Secondo l'appropriato termine di John Russell, lo spazio è "negoziato" dalla definizione e ridefinizione del rapporto del campo tonale… i residui della relazione tra figura e sfondo rimangono in vigore, sebbene ora l'enfasi sia posta nel conservare l'integrità della superficie, mentre si combinano incidenti di superficie con l'illusione spaziale all'interno.[53]

I primi quadri di *Ocean Park*, per esempio *Ocean Park No. 7*, *No. 10* e *No. 21*, hanno uno spazio centrale che retrocede – il che è stato spesso paragonato a quello che si trova ne: *The French Window*, 1914 e *The Piano Lesson*, 1916 di Matisse. *Ocean Park No. 14*, 1963, e *Ocean Park No. 43*, 1971 presentano reminiscenze dei quadri interni/esterni ispirati a quelli di Leningrado, con elementi curvilinei che scolpiscono le aree di colore – espediente calligrafico che si può rintracciare fin dalle opere di *Albuquerque*, *Urbana* e *Berkeley*. La forma ad "Y" e ad "Y" capovolta che si trova in *Black Table*, 1960 e in *View from the Porch*, 1959 ricorre anche in *Ocean Park No. 27, No. 32* e altri.

> Egli è…abilissimo a dominare vaste zone di colore atmosferico sottilmente modulato, lasciando trapelare il caldo splendore di strati sotterranei di colore attraverso fredde superfici o, viceversa, rivelando la presenza minacciosa di un'ombra gelida sotto un esterno ardente. Inoltre, Diebenkorn è uno di quegli artisti che hanno la speciale capacità di ispirare ricordi storico-artistici. Non è solo che egli riflette onestamente

l'influenza di Hopper, Still, de Kooning, Rothko, Mondrian e soprattutto Matisse, ma, per mezzo di una pura e semplice capacità ri-creativa, è anche capace di far ricordare quello che una volta sembrava così elettrizzante nelle prime fasi del modernismo che egli rievoca.[54]

Mano mano che la serie progredisce, le tele divengono più chiare, più sintetiche, i colori diventano più morbidi, la stesura prima e quella finale più delicata.[55] La serenità delle loro ricche superfici aiuta a rendere manifesta la passione intelligente di Diebenkorn per la luce e la linea; "i dipinti astratti mi permettono una luce che permea il tutto, cosa che non mi era possibile nelle opere figurative".[56]

I quadri di Diebenkorn sono sempre stati sinceri, mostrando in modo onesto e deliberato il metodo di composizione.

Il metodo di lavoro dell'artista: fare lo schizzo direttamente sulla superficie, dipingere, correggere, raffinare, cancellare, invertire, ridipingere – risulta in una superficie dipinta a molti strati ed eseguita in maniera diretta. La superficie si arricchisce con i segni della sua stessa esperienza permettendo ai fantasmi degli strati precedenti e agli esperimenti lineari di emergere dal suo corpo semi-trasparente.[57]

Ha scritto John Russell della serie di *Ocean Park:* "Sono mondi composti questi che Diebenkorn ci pone davanti…sono la registrazione, vera e completa, del discorso di un uomo con il dipingere…[58]

Ad un momento qualsiasi della sua ricerca, Richard Diebenkorn avrebbe potuto decidere di abbandonarla, di rimanere con quanto egli sapeva che avrebbe "funzionato" per fare dei buoni quadri. Ma non lo ha mai fatto, non ci ha mai annoiato con ripetizioni, con quadri le cui sfumature sono la sola giustificazione allo loro esistenza. Diebenkorn espande costantemente i limiti del suo lavoro; mette a repentaglio quello che già conosce per fare delle scoperte. Alla domanda sul perchè dipingesse, egli rispose una volta:

E una meravigliosa esperienza violare la mia concezione globale di che cosa debba essere un quadro e scoprire che, in questo processo, sono cambiato.[59]

Linda L. Cathcart

Ringraziamenti

Vorrei estendere il mio apprezzamento sincero a tutti coloro che hanno collaborato alla realizzazione di questo progetto: Robert T. Buck Jr., in qualità sia di Commissario degli Stati Uniti per la Biennale che di Direttore della Albright-Knox Art Gallery: Wilder Green, Direttore dell'American Federation of Arts; Thomas Messer, Presidente dell'International Exhibitions Committee. I miei collaboratori per questo progetto includono: Laura Fleischmann, assistente alle ricerche, Karen Spaulding, che cura le pubblicazioni, Serena Rattazzi, coordinatrice delle relazioni pubbliche; Norma Bardo, segretaria, Annette Masling, bibliotecaria e la sua assistente Margaret Cantrick. Tra il personale dell'American Federation of Arts, ho avuto la completa collaborazione da Melissa Meighan, coordinatrice della sezione americana della Biennale di Venezia 1978 e archivista, Konrad Kuchel, coordina-
tore dei prestiti, Mary Ann Monet, segretaria e Michael Shroyer, *designer.* Ringrazio le numerose gallerie e musei che hanno offerto preziosi schedari e fotografie, incluse le gallerie M. Knoedler & Co. e Blum/Helman.
Uno speciale ringraziamento va a coloro che hanno, con straordinaria generosità prestato opere per questa mostra, che non si sarebbe potuta portare a termine senza la loro fiducia, a Phyllis Diebenkorn per la sua infinita pazienza e a Richard Diebenkorn per i suoi quadri meravigliosi.
L.L.C.
Questo saggio è una versione ampliata di "Reaction and Response" (Reazione e partecipazione), in *Richard Diebenkorn: Paintings and Drawings 1943-1976,* Albright-Knox Art Gallery, Buffalo, 1976.

Note

1. Maurice Tuchman, "Diebenkorn's Early Years," *Richard Dieben-korn: Paintings and Drawings, 1943-1976* (Albright-Knox Art Gallery, Buffalo, 1976) p. 5.

2. Ibid., p. 5.

3. Ibid, p. 6.

4. Ibid.

5. Ibid., p. 7.

6. L'opera riprodotta di Motherwell era: "The room"

7. Frederick Wight, "The Phillips Collection – Diebenkorn, Woelffer, Mullican: A Discussion," *Artforum*, vol. 1, no. 10, Apr. 1963, p. 26.

8. Tuchman, "Diebenkorn's Early Years," p. 7.

9. Peter Plagens, *Sunshine Muse* (Praeger, New York, 1974) p. 36.

10. Tuchman, "Diebenkorn's Early Years," p. 10.

11. Ibid.

12. Ibid., p. 12.

13. Ibid., p. 7.

14. Douglas Mac Agy aveva invitato Diebenkorn a ritornare come membro della facoltà prima che partisse per Woodstock.

15. Tuchman, "Diebenkorn's Early Years," p. 8.

16. "L'incudine e la chiave inglese sono elementi che si possono far risalire ai suoi vividi ricordi di un fabbro ferraio durante le estati della sua fanciullezza, trascorse con la nonna a Woodside, California"? Tuchman, "Diebenkorn's Early Years," p. 13.

17. Tuchman, "Diebenkorn's Early Years," p. 13.

18. Ibid.

19. Gerald Nordland, *Richard Diebenkorn* (Washington Gallery of Modern Art, Washington, D.C., 1964) p. 8.

20. Molti dei dipinti di questo periodo sono intitolati *Albuquerque*; altri tuttavia hanno altri nomi: *Miller 22, Untitled,* etc.

21. Tuchman, "Diebenkorn's Early Years," p. 14.

22. Nordland, *Richard Diebenkorn*, p. 10.

23. Tuchman, "Diebenkorn's Early Years," p. 13.

24. Ibid., p. 15.

25. Incluse in tale mostra erano le opere: *The Red Studio, Goldfish, Goldfish and sculpture, Woman on a high stool, The piano lesson, The Moroccans* e *Tea*.

26. Tuchman, "Diebenkorn's Early Years," p. 18.

27. Ibid.

28. Ibid.

29. Jules Langsner, "Art News from Los Angeles: Diebenkorn and Randall," *Art News*, vol. 51, no. 7 (November 1952) p. 61.

30. Tuchman, "Diebenkorn's Early Years," p. 23.

31. Gerald Nordland, "The Figurative Works of Richard Dieben-korn," *Richard Diebenkorn: Paintings and Drawings, 1943-1976* (Albright-Knox Art Gallery, Buffalo, 1976) p. 26.

32. Tuchman, "Diebenkorn's Early Years," p. 23.

33. Dore Ashton, "Young Painters in Rome," *Arts Digest*, vol. 29, no. 17, (June 1955) p. 6.

34. Nordland, "The Figurative Works of Richard Diebenkorn," p. 26.

35. Diebenkorn citato in Nordland: "The Figurative Works Of Richard Diebenkorn," p. 26.

36. Gail R. Scott, *New Paintings by Richard Diebenkorn*, (Los Angeles County Museum of Art, Los Angeles, 1969) p. 6.

37. Nordland, "The Figurative Works of Richard Diebenkorn," p. 27.

38. Nordland, *Richard Diebenkorn, The Ocean Park Series: Recent Work*, (Marlborough Gallery, New York, 1971), p. 10.

39. Betty Turnbull, *The Last Time I Saw Ferus*, (Newport Harbor Art Museum, Newport Beach, 1976) n.p.

40. Paul Mills, *Contemporary Bay Area Figurative Painters* (The Oakland Art Museum, Oakland, 1957) p. 12.

41. Ellen Johnson, "Diebenkorn's Woman by a Window," (*Allen Memorial Art Museum Bulletin Oberlin College*), vol. 16, no. 1, Fall 1958, p. 19.

42. Hilton Kramer, "Pure and Impure Diebenkorn," *Arts Magazine* vol. 62, no. 8, p. 47.

43. Ibid.

44. Diebenkorn, Diario, citato in Nordland: "The Figurative Works of Richard Diebenkorn," pp. 34-35.

45. Gifford Phillips, *Richard Diebenkorn*, (The Phillips Collection, Washington, D.C., 1961), n.p.

46. Nordland, "The Figurative Works of Richard Diebenkorn," p. 34.

47. J[ames] M[onte], "Reviews: Drawings by Elmer Bischoff, Richard Diebenkorn and Frank Lobdell, *Artforum*, vol. 2, no. 1, 1963, p. 7.

48. Nordland, "Richard Diebenkorn," *Artforum*, vol. 3, no. 4, Jan. 1965, p. 25.

49. Nordland, "The Figurative Works of Richard Diebenkorn," pp. 39-40.

50. Philip Leider, "Diebenkorn Drawings at Stanford," *Artforum*, vol. 2, no. 11, May 1964, p. 42.

51. In effetti i quadri in esistenza non sono esattamente 105: alcuni sono stati distrutti, altri ri-dipinti o ri-numerati.

52. Tuchman, "Diebenkorn's Early Years," p. 6.

53. Robert T. Buck, Jr., "The Ocean Park Paintings," *Richard Diebenkorn: Paintings and Drawings 1943-1976* (Albright-Knox Art Gallery, Buffalo, 1976) p. 46.

54. Nancy Marmer, "Richard Diebenkorn: Pacific Extensions," *Art in America*, vol. 66, no. 1, Jan.-Feb. 1978, p. 98.

55. In realtà non vi sono esattamente 105 dipinti; alcuni sono stati distrutti, altri ridipinti o rinumerati.

56. Nordland, *Richard Diebenkorn, The Ocean Park Series: Recent Work*, p. 11.

57. Ibid.

58. John Russell, *Richard Diebenkorn, The Ocean Park Series: Recent Work* (Marlborough Fine Art Ltd., London, 1973), p. 8.

59. Nordland, *Richard Diebenkorn, The Ocean Park Series: Recent Work*, p. 10.

Catalogue

Height precedes width. Ocean Park refers to a section of Santa Monica, California, where the artist has had his studio since 1967.

Paintings

1. *Ocean Park No. 28,* 1970
 oil on canvas, 93 x 81″ (236.2 x 205.7 cm.)
 Private collection

2. *Ocean Park No. 32,* 1970
 oil on canvas, 93 x 81″ (236.2 x 205.7 cm.)
 Collection Stan Picher and Wally Goodman

3. *Ocean Park No. 38,* 1971
 oil on canvas, 100 x 81″ (254 x 205.7 cm.)
 Collection Mr. and Mrs. Gifford Phillips, New York

4. *Ocean Park No. 48,* 1971
 oil on canvas, 100 x 81″ (254 x 205.7 cm.)
 Collection Mr. and Mrs. John Rex, Carpenteria, California

5. *Ocean Park No. 64,* 1973
 oil on canvas, 100 x 81″ (254 x 205.7 cm.)
 Collection Museum of Art, Carnegie Institute, Pittsburgh, Pennsylvania

6. *Ocean Park No. 66,* 1973
 oil on canvas, 93 x 81″ (236.2 x 205.7 cm.)
 Collection Albright-Knox Art Gallery, Buffalo, New York, Gift of Seymour H. Knox, 1974

7. *Ocean Park No. 67,* 1973
 oil on canvas, 100 x 81″ (254 x 205.7 cm.)
 Collection Mr. and Mrs. Donald B. Marron

8. *Ocean Park No. 68,* 1974
 oil on canvas, 81 x 93″ (205.7 x 236.2 cm.)
 From the Collection of Mrs. Harry Lynde Bradley, Milwaukee, Wisconsin

9. *Ocean Park No. 80,* 1975
 oil on canvas, 66 x 48″ (167.6 x 121.9 cm.)
 Collection Mr. and Mrs. Jerome Serchuck

10. *Ocean Park No. 82,* 1975
 oil on canvas, 70 x 44¾″ (177.8 x 113.6 cm.)
 Private collection

11. *Ocean Park No. 83,* 1975
 oil on canvas, 100 x 81″ (254 x 205.7 cm.)
 Collection Corcoran Gallery of Art, Washington, D.C.,
 Purchased with the aid of funds from the National Endowment for the Arts, The Wm. A. Clark Fund and Margaret M. Hitchcock

12. *Ocean Park No. 88,* 1975
 oil on canvas, 100 x 81″ (254 x 205.7 cm.)
 Collection Mr. and Mrs. William C. Janss, Sun Valley, Idaho

13. *Ocean Park No. 94,* 1976
 oil on canvas, 93 x 81″ (236.2 x 205.7 cm.)
 Collection Mr. and Mrs. Richard Diebenkorn, Santa Monica, California

14. *Ocean Park No. 96,* 1977
 oil on canvas, 93 x 85″ (236.2 x 215.9 cm.)
 Collection The Solomon R. Guggenheim Museum, New York:
 Purchased with the aid of funds from the National Endowment for the Arts: Matching Gift, Mr. & Mrs. Stuart M. Speiser and Louis and Bessie Adler Foundation, Inc., Seymour M. Klein, President

15. *Ocean Park No. 100,* 1977
 oil on canvas, 90¼ x 80″ (229.2 x 203.2 cm.)
 Collection Mr. and Mrs. Donald B. Marron

16. *Ocean Park No. 105,* 1978
 oil on canvas, 93 x 100″ (236.2 x 254 cm.)
 Courtesy M. Knoedler & Co., New York

Drawings

17. *Untitled,* 1977
 oil on mylar, 35⅜ x 22″ (97.5 x 56 cm.)
 Collection Dr. L. W. Brady, Pennsylvania

18. *Untitled,* 1977
 charcoal and oil on paper, 23½ x 18½″ (59.7 x 47 cm.)
 Courtesy M. Knoedler & Co., New York

19. *Untitled,* 1977
 oil on mylar, 35½ x 22⅛″ (90.2 x 56.2 cm.)
 Courtesy M. Knoedler & Co., New York

20. *Untitled,* 1977
 oil and charcoal on paper, 31 x 21″ (78.8 x 53.4 cm.)
 Courtesy M. Knoedler & Co., New York

21. *Untitled,* 1977
 charcoal on paper, 27¼ x 17″ (69.2 x 43.2 cm.)
 Courtesy M. Knoedler & Co., New York

22. *Untitled,* 1977
 charcoal on paper, 29 x 21″ (73.7 x 53.4 cm.)
 Courtesy M. Knoedler & Co., New York

23. *Untitled,* 1977
 oil and charcoal on paper, 29 x 22⅞″ (73.7 x 58.1 cm.)
 Courtesy M. Knoedler & Co., New York

24. *Untitled,* 1978
 charcoal and oil on paper, 30½ x 16⅞″ (77.5 x 42.9 cm.)
 Collection Mr. J. Falvy, California

25. *Untitled,* 1978
 charcoal and oil on paper, 23⅜ x 16⅞″ (59.4 x 42.9 cm.)
 Courtesy M. Knoedler & Co., New York

26. *Untitled,* 1978
 oil on paper, 30 x 20″ (76.2 x 50.8 cm.)
 Courtesy M. Knoedler & Co., New York

Plates

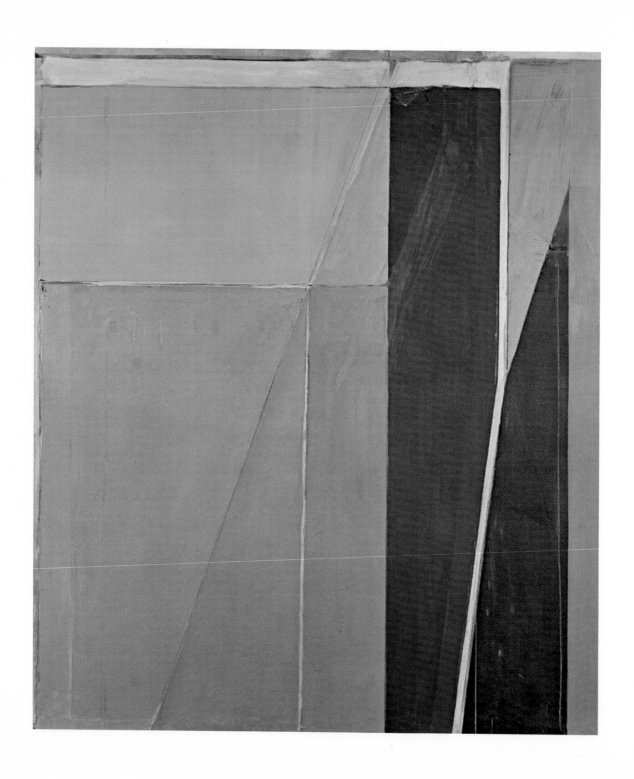

1. *Ocean Park No. 28,* 1970

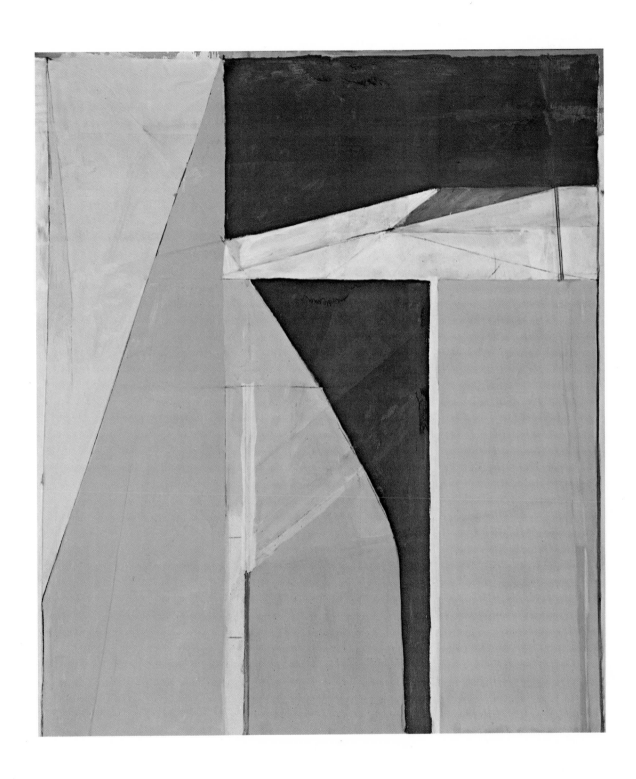

2. *Ocean Park No. 32*, 1970

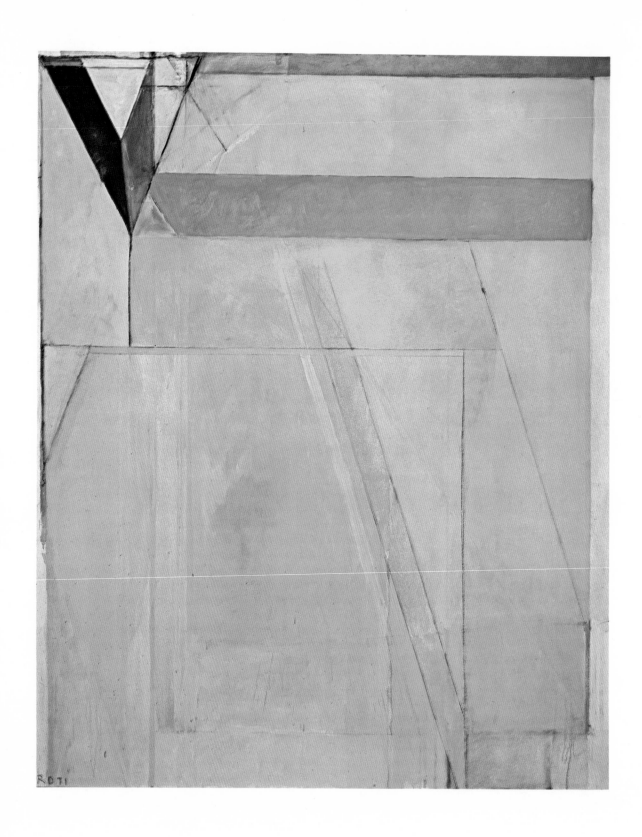

3. *Ocean Park No. 38*, 1971

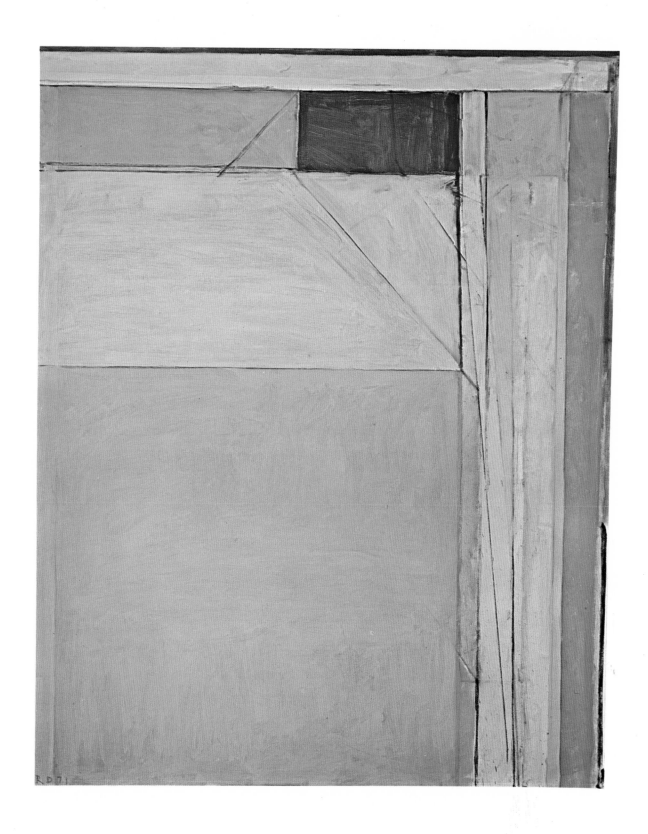

4. *Ocean Park No. 48*, 1971

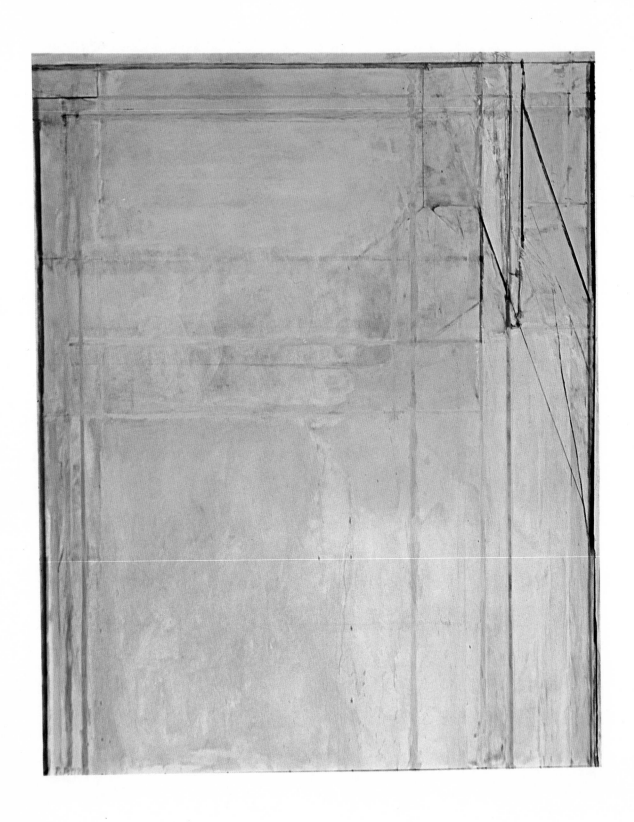

5. *Ocean Park No. 64, 1973*

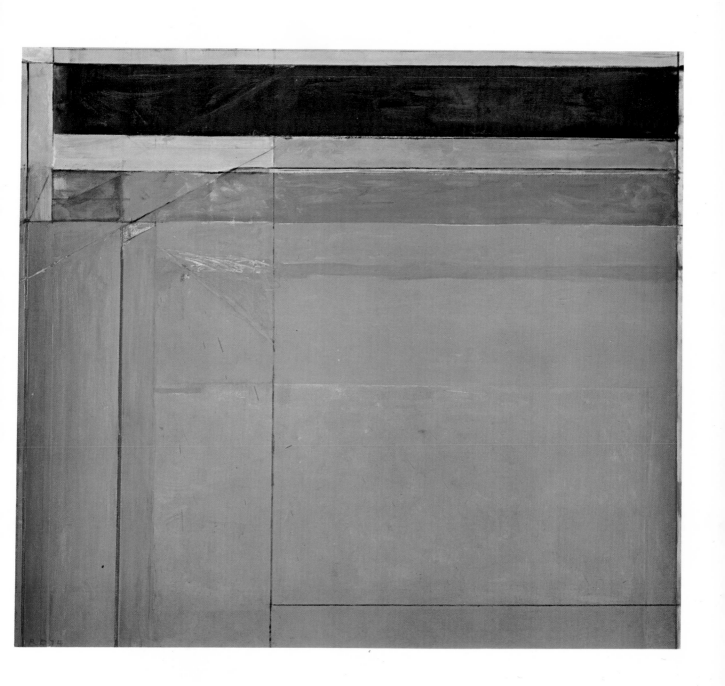

8. *Ocean Park No. 68*, 1974

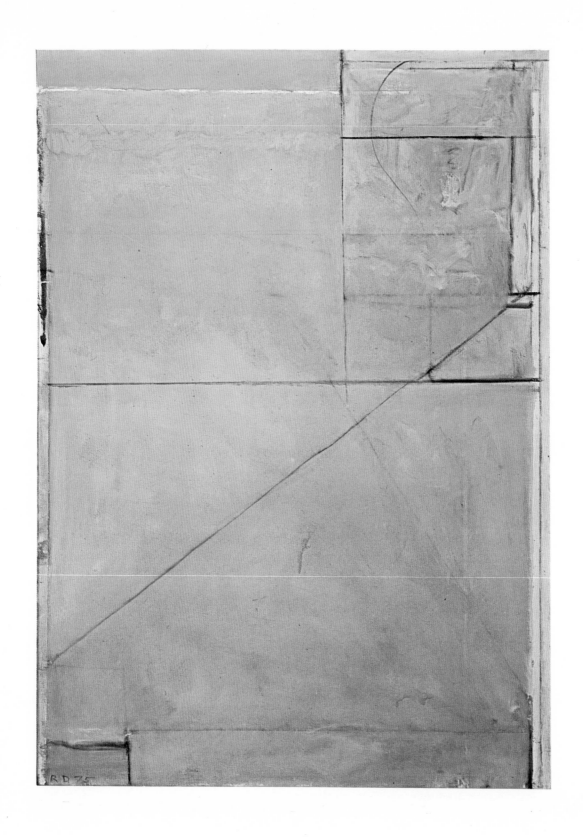

9. *Ocean Park No. 80, 1975*

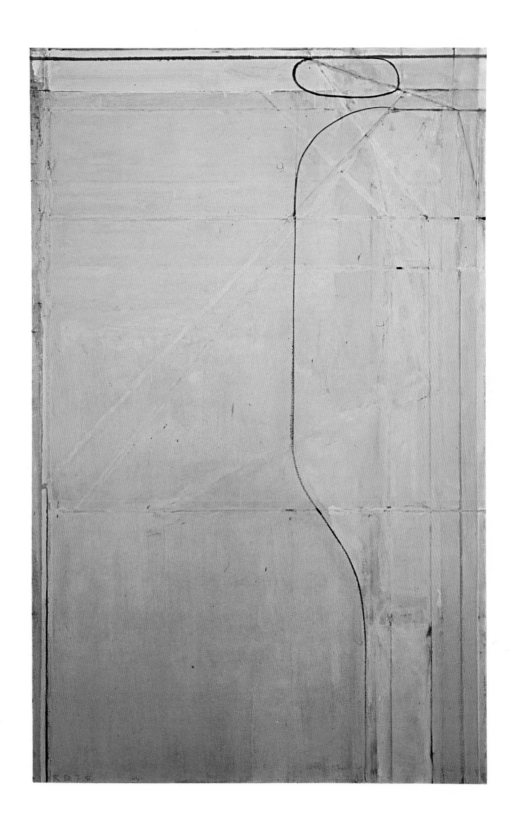

10. *Ocean Park No. 82*, 1975

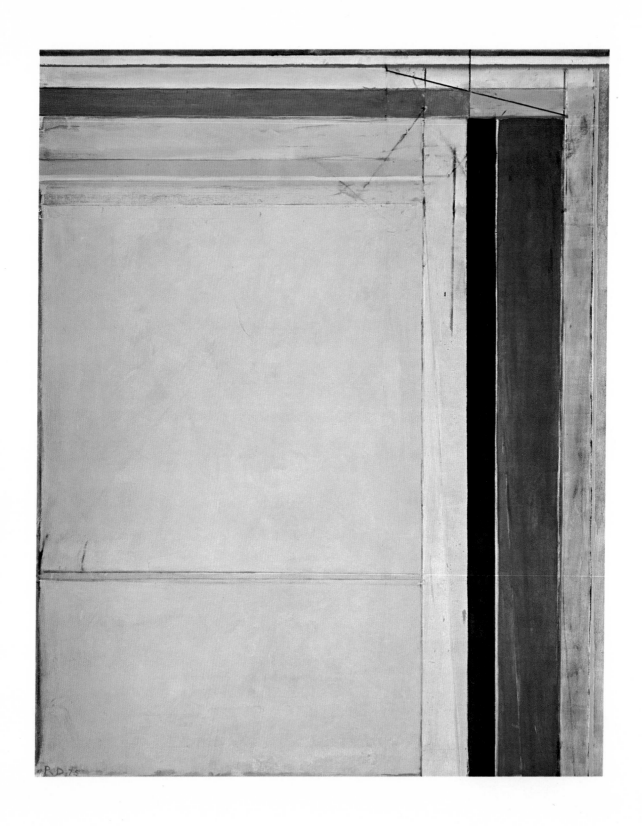

11. *Ocean Park No. 83*, 1975

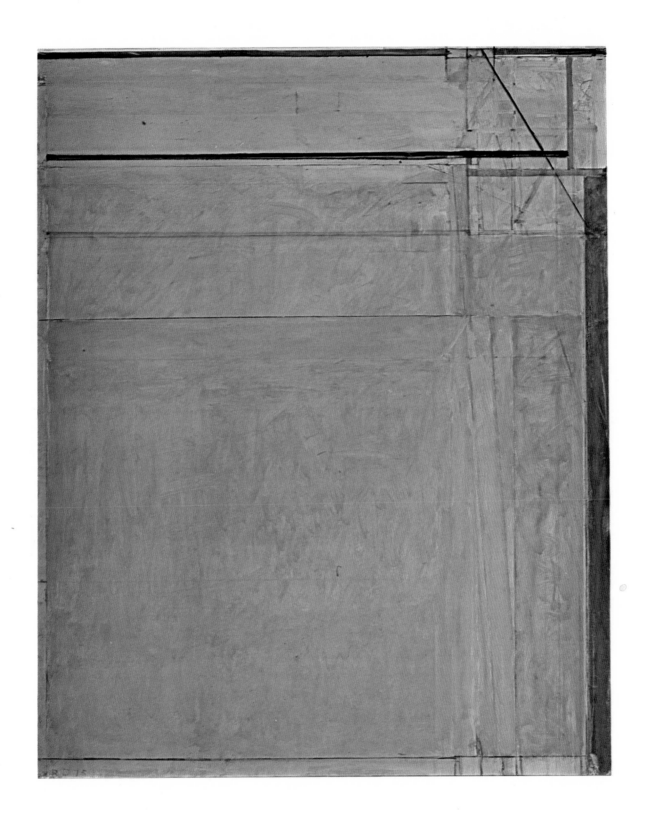

12. *Ocean Park No. 88*, 1975

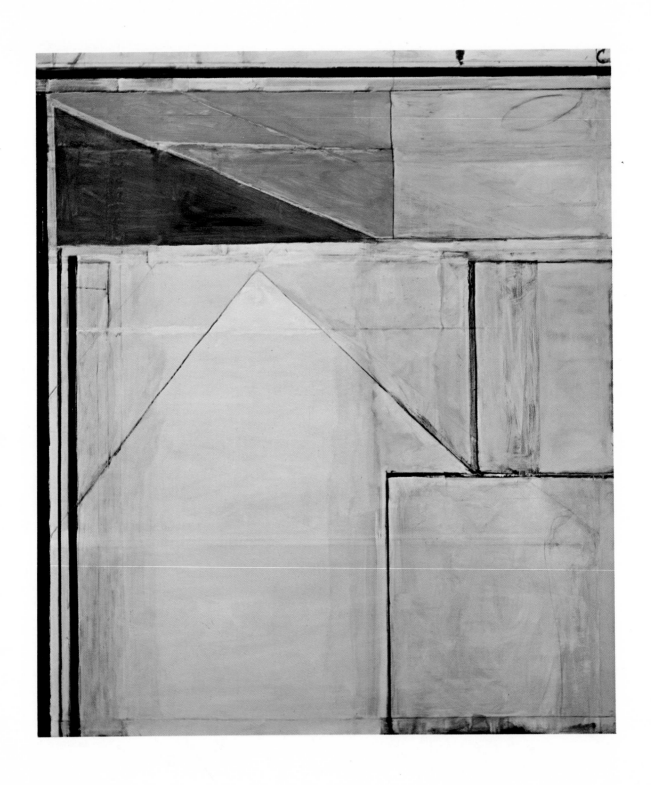

13. *Ocean Park No. 94,* 1976

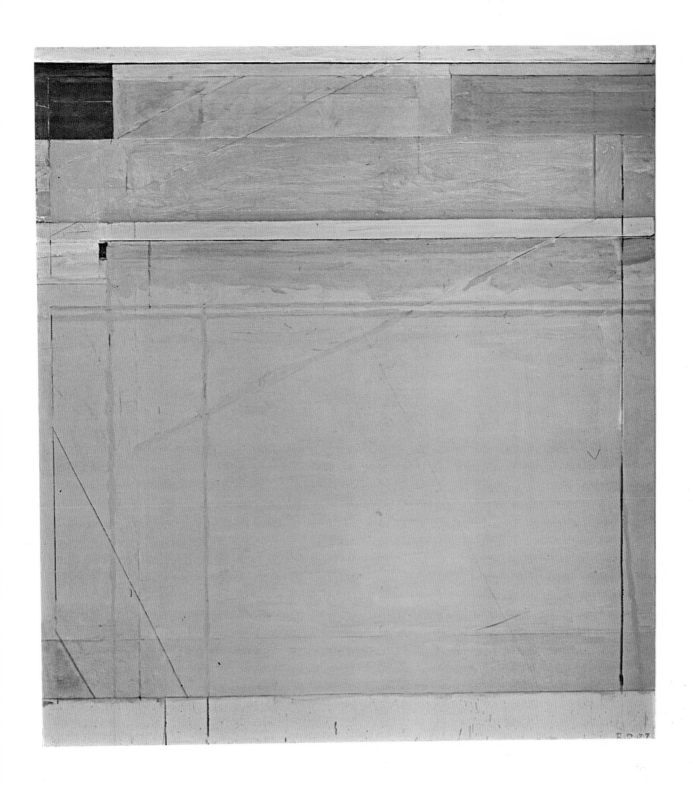

14. *Ocean Park No. 96,* 1977

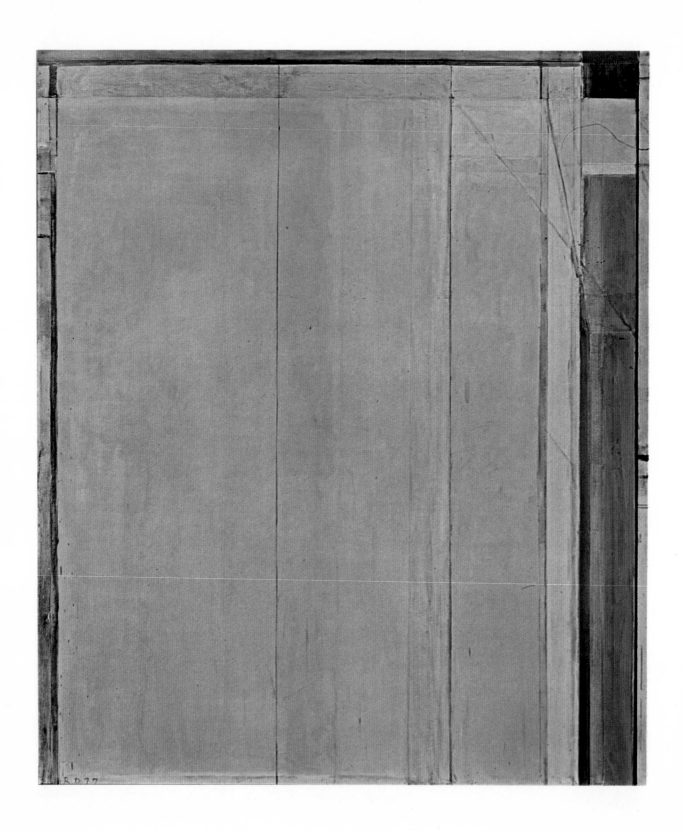

15. *Ocean Park No. 100*, 1977

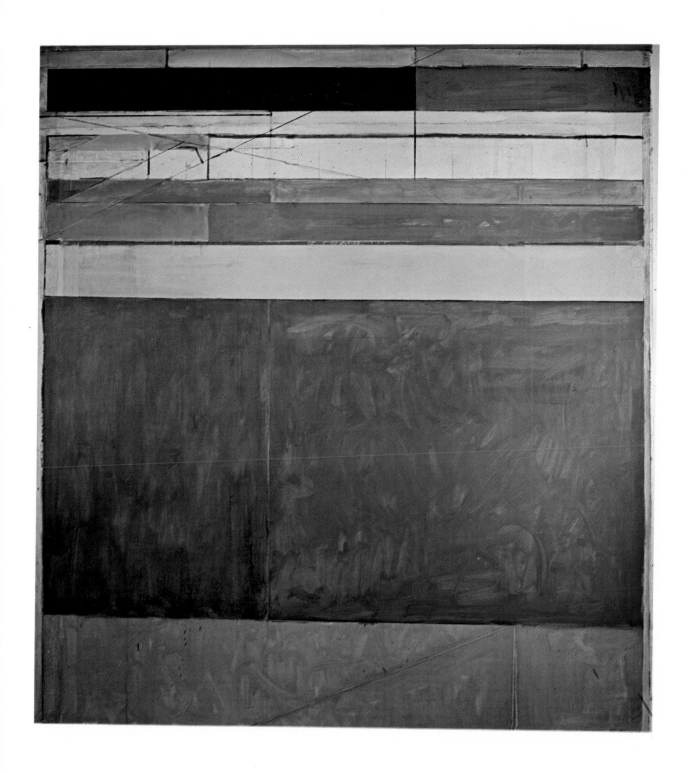

16. *Ocean Park No. 105*, 1978

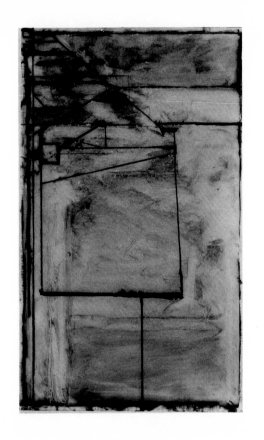

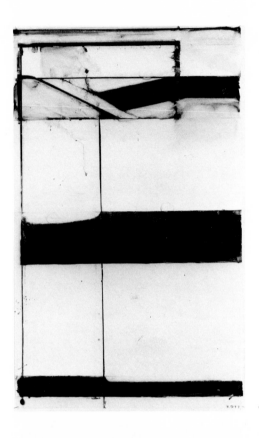

19. *Untitled*, 1977

17. *Untitled*, 1977

18. *Untitled*, 1977

20. *Untitled*, 1977 21. *Untitled*, 1977

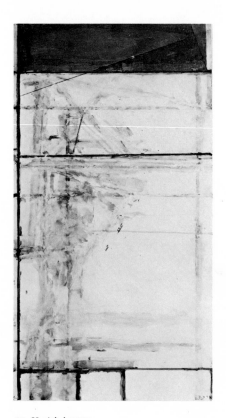

23. *Untitled,* 1977

22. *Untitled,* 1977

24. *Untitled,* 1978

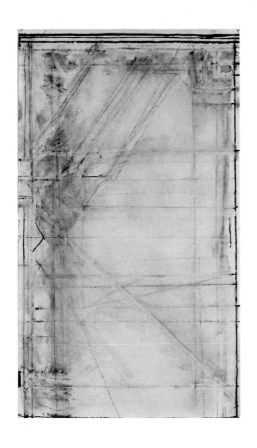

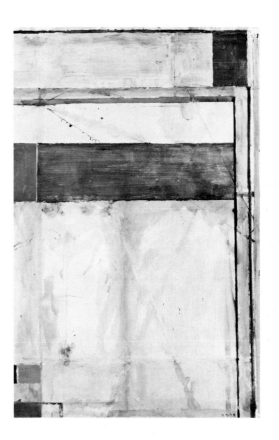

25. *Untitled*, 1978 26. *Untitled*, 1978

Photo credits

Chronology

1922 Born April 22, Portland, Oregon. Mother, Dorothy Stephens; father, Richard Clifford Diebenkorn, sales executive.

1924-
1939 Moves to San Francisco. Frequently spends childhood summers with grandmother who encourages his interest in art. Makes illustrations inspired by adventure stories. Attends Lowell High School for gifted children.

1940 Enrolls in liberal arts studies at Stanford University, Palo Alto, California.

1943 At Stanford, studies watercolor with Daniel Mendelowitz and oil painting with Victor Arnautoff; works both in the studio and from nature. Sees the work of Arthur G. Dove, Edward Hopper, Charles Scheeler, etc. Visits Sarah Stein's home; first sees Picasso, Matisse and Cézanne. Marries Phyllis Gilman. Spring, joins Marine Corps; fall, transfers to University of California at Berkeley under auspices of Marine Corps. Studies physics; art teachers: Erle Loran, Worth Ryder and Eugene Neuhaus. Receives B.A. degree. Earliest extant painting, *Palo Alto Circle.* Transferred to Parris Island, South Carolina.

1944 Transferred to North Carolina for four months; paints and draws portraits of fellow Marines. Officer Candidate School, Quantico, Virginia. Frequents The Phillips Collection, Washington, D. C., sees Picasso, Braque and Bonnard; impressed by Matisse's *The Studio, Quai St. Michel* and Cézanne's *Mont Sainte-Victoire.* Sees sculpture by Arp and Klee's *Christmas Picture,* Philadelphia Museum of Art. Comes across reproductions of Baziotes and Motherwell in *DYN* magazine. Transferred to Hawaii for training as war artist.

1945 Discharged from Marines; returns to California.

1946 January, enrolls, California School of Fine Arts, San Francisco. Teachers: Elmer Bischoff, David Park, and Hassel Smith. Daughter Gretchen born. September, moves to Woodstock, New York on Albert Bender Grant-in-Aid fellowship; neighbors: Baziotes, Raoul Hauge and Tomlin. Makes several trips to New York City to visit art galleries and museums. Meets Franz Kline.

1947 Spring, returns to California. September, teaches life drawing, drawing and composition, CSFA. Sees Clyfford Still retrospective, California Palace of the Legion of Honor, San Francisco. Reads Clement Greenberg's criticism in *The Nation* and *Partisan Review.* Son Christopher born.

1948 One-artist exhibition, California Palace of the Legion of Honor. Emmanuel Walter Purchase Prize for *Composition,* 1948 at San Francisco Museum of Art, *67th Painting and Sculpture Annual.* Meets Rothko. First sees reproductions of de Kooning's black and white paintings. Begins friendship with Edward Corbett.

1949 Exhibits with Hassel Smith, Lucien Laubaudt Gallery, San Francisco.

1950-
1951 January, enrolls, University of New Mexico, Albuquerque, M.F.A. program. Begins *Albuquerque* paintings. Los Angeles

dealer and collector Paul Kantor visits studio, purchases several works. Dorothy Miller, Curator at The Museum of Modern Art, New York, visits studio. Masters thesis exhibition, receives degree.

1952 Spring, returns to California. Summer, sees Matisse retrospective, Los Angeles. Fall, moves to Champaign-Urbana; teaches drawing to architecture students, University of Illinois. Begins *Urbana* paintings. One-artist exhibition, Paul Kantor Gallery, Los Angeles.

1953 Summer, moves to Manhattan, rents studio on East 12th Street. Kline introduces him to Eleanor Poindexter Gallery. Fall, returns to Berkeley; Bischoff and Park now painting figuratively. Teaches at California College of Arts and Crafts. Begins *Berkeley* paintings near end of year.

1954 Receives Abraham Rosenberg Fellowship. Joins Park, Bischoff, Frank Lobdell in weekly figure drawing sessions. Included in *Younger American Painters,* The Solomon R. Guggenheim Museum, New York. One-artist exhibition, Paul Kantor Gallery.

1955 Begins painting figuratively. Shows in III São Paulo Bienal, Brazil; Oberlin Art Museum (group exhibition), Poindexter Gallery, New York. Exhibits only abstract work.

1956 Builds new studio in Berkeley. Herschel B. Chipp writes major article, "Diebenkorn Paints a Picture," for *Art News.* One-artist exhibition, *Berkeley* paintings, Poindexter Gallery. Figurative work first exhibited, Oakland Art Museum, California.

1957-
1958 Exhibits Ferus Gallery, Los Angeles; *Contemporary Bay Area Figurative Painting,* Oakland Art Museum; *Modern Painting, Drawing, and Sculpture Collected by Louise and Joseph Pulitzer, Jr.,* Knoedler & Co., New York; Annual Exhibition, Whitney Museum of American Art, New York.

1960 Retrospective, sixty-six paintings, 1952-1960, Pasadena Art Museum, California. One-artist exhibition, California Palace of the Legion of Honor.

1961 First exhibits figurative paintings in New York, Poindexter Gallery. Survey (three years work), The Phillips Collection, Washington, D. C. Guest artist, Tamarind Lithography Workshop, Los Angeles.

1962 Fellowship at Tamarind.

1963 One-artist exhibitions, M.H. de Young Memorial Museum, San Francisco and Poindexter Gallery.

1964-
1965 Travels to Soviet Union on U. S. State Department Cultural Exchange Program. Sees Matisse paintings in the Schuhkin and Hermitage collections. Artist-in-residence, Stanford University. Makes drawings for exhibition there and at Paul Kantor Gallery. Retrospective, Washington Gallery of Modern Art, Washington, D. C. No paintings dated this year.

1966 Sees major Matisse retrospective, Los Angeles County Museum of Art. Moves to Southern California; rents studio, Ocean Park section of Santa Monica. Professor of Art, University of California at Los Angeles to 1973.

1967 Begins large abstract paintings, *Ocean Park* series which continues to the present.

1968 First exhibition of *Ocean Park* paintings, Poindexter Gallery. Carol H. Beck Gold Medal Award, Pennsylvania Academy of the Fine Arts, Philadelphia. Exhibits 34 Venice Biennale. Undergoes back operation.

1969- *Ocean Park* paintings widely exhibited. One-artist exhibitions,
1970 Los Angeles County Museum of Art and Poindexter Gallery.

1971 One-artist exhibition, Marlborough Gallery, New York.

1972- One-artist exhibitions, Marlborough Gallery, London and
1975 Marlborough Gallery, New York. Large exhibition, *Ocean Park* paintings, San Francisco Museum of Art. Numerous other one-artist and group exhibitions.

1976 Exhibition of monotypes, UCLA. Major retrospective, Albright-Knox Art Gallery, Buffalo, New York; exhibition tours throughout United States.

Cronologia

1922 Nato il 22 Aprile a Portland, Oregon, da Richard Clifford Diebenkorn, dirigente di vendita e da Dorothy Stephens.

1924-1939 Si trasferisce a San Francisco. Trascorre parecchie estati della sua fanciullezza con la nonna che incoraggia il suo interesse all'arte. Fa illustrazioni ispirate da storie di avventura. Frequenta la Lowell High School per ragazzi dotati.

1940 Si iscrive alla Stanford University di Palo Alto, California e segue studi di arti liberali.

1943 A Stanford studia acquerello con Daniel Mendelowitz e pittura a olio con Victor Arnautoff; lavora nello studio e dal vero. Vede le opere di Arthur G. Dove, Edward Hopper, Charles Sheeler, ecc. Visita la casa di Sarah Stein; per la prima volta vede Picasso, Matisse e Cézanne. Sposa Phyllis Gilman. Nella primavera si arruola nel corpo dei "Marines"; nell'atunno si trasferisce all'Università della California a Berkeley sotto gli auspici del corpo dei "Marines." Studia fisica. I suoi insegnanti d'arte sono Erle Loran, Worth Ryder ed Eugene Neuhaus. Ottiene il titolo di Bachelor of Arts. Di questo periodo rimane il primo dipinto, *Palo Alto Circle*. Si trasferisce a Parris Island, South Carolina.

1944 Si trasferisce in North Carolina per quattro mesi: dipinge e disegna ritratti di commilitoni "Marines." E alla scuola degli allievi ufficiali a Quantico, Virginia. Frequenta la Phillips Collection a Washington D.C., vede Picasso, Braque e Bonnard; è impressionato da *Studio* e *Quai S. Michel* di Matisse e *Mont Sainte-Victoire* di Cézanne. Vede la scultura di Arp e *Christmas Picture* di Klee nel Museum of Art di Filadelfia. Vede riproduzioni di Baziotes e Motherwell nella rivista *DYN*. Si trasferisce in Hawaii per specializzarsi come artista di guerra.

1945 Congedato dai "Marines," ritorna in California.

1946 In gennaio si iscrive alla California School of Fine Arts di San Francisco. Sono suoi insegnanti Elmer Bischoff, David Park e Hassel Smith. Nasce la figlia Gretchen. In settembre si trasferisce a Woodstock, New York, con una borsa di studio Albert Benter. Suoi vicini: Baziotes, Raoul Hauge e Tomlin. Si reca spesso a New York per visitare galleria d'arte e musei. Fa la conoscenza di Franz Kline.

1947 Nella primavera ritorna in California. In settembre insegna disegno dal vero e disegno e composizione alla California School of Fine Arts. Vede la retrospettiva di Clyfford Still, nel California Palace of the Legion of Honor, a San Francisco. Legge la critica di Clement Greenberg nelle riviste *The Nation* e *Partisan Review*. Nasce il figlio Christopher.

1948 Mostra personale al California Palace of the Legion of Honor. Riceve il premio di acquisto emanuele Walter per *Composition, 1948*, al San Francisco Museum of Art, 67a Mostra Annuale di Pittura e Scultura. Fa la conoscenza di Rothko. Per la prima volta vede la riproduzioni delle pitture in bianco e nero di de Kooning. Inizia l'amicizia con Edward Corbett.

1949 Mostre con Hassel Smith alla Lucien Laubaudt Gallery a San Francisco.

1950-1951 In gennaio si iscrive all'Università del New Mexico ad Albuquerque nel programma per il titolo di Master of Fine Arts. Inizia i dipinti *Albuquerque*. Il mercante d'arte e collezionista Paul Kantor di Los Angeles visita il suo studio ed acquista parecchie opere. Dorothy Miller, conservatrice del Museum of Modern Art di New York visita il suo studio. Presenta una mostra come tesi e riceve il titolo di Master.

1952 Nella primavera ritorna in California. Nell'estate vede la retrospettiva di Matisse a Los Angeles. Nell'autunno si trasferisce a Champaign-Urbana; insegna disegno a studenti di architettura dell'Università dell'Illinois. Inizia i dipinti *Urbana*. Mostra personale alla galleria Paul Kantor di Los Angeles.

1953 Nell'estate si trasferisce a Manhattan, affitta uno studio alla 12a Strada Est. Kline lo presenta alla Galleria Eleanor Poindexter. Nell'autunno ritorna a Berkeley e dipinge in stile figurativo. Insegna al California College of Arts and Crafts. Inizia i dipinti *Berkeley* verso la fine dell'anno.

1954 Riceve la borsa di studio Abraham Rosenberg, si unisce a Park, Bischoff, Frank Lobdell in sessioni settimanali di disegno figurativo. E incluso nella mostra *Giovani Pittori Americani* del Solomon R. Guggenheim Museum di New York. Mostra personale alla galleria Paul Kantor.

1955 Inizia a dipingere figurativamente. Partecipa alla III Biennale di San Paolo, Brasile, alla collettiva dell'Oberlin Art Museum ed espone alla Poindexter di New York. Espone solo opere astratte.

1956 Costruisce un nuovo studio a Berkeley. Herschel B. Chipp scrive un importante articolo "Diebenkorn dipinge un quadro" per *Art News*. Mostra personale dei dipinti *Berkeley* alla galleria Poindexter. La sua opera figurativa è esposta per la prima volta all' Oakland Art Museum in California.

1957-1958 Espone alla galleria Ferus di Los Angeles, alla mostra di *Pittura Figurativa Contemporanea dell'Area della Baia* nell'Oakland Art Museum, alla mostra *Pitture, Sculture e Disegno Moderni Raccolti da Louise e Joseph Pulitzer Jr.* alla Knoedler & Co. New York, alla mostra annuale del Whitney Museum of American Art di New York.

1960 Mostra retrospettiva di sessantasei dipinti, 1952-1960, al Pasadena Art Museum, California. Mostra personale al California Palace of the Legion of Honor.

1961 Per la prima volta espone dipinti figurativi a New York, alla galleria Poindexter. Rassegna (lavoro di tre anni) alla Phillips Collection Washington, D.C. Artista ospite nello studio litografico Tamarind a Los Angeles.

1962 Borsa di studio a Tamarind.

1963 Mostre personali al M.H. De Young Memorial Museum di San Francisco e alla galleria Poindexter.

1964- Viaggia nell'Unione Sovietica con il programma di scambi
1965 culturali del Dipartimento di Stato degli Stati Uniti. Vede i dipinti di Matisse nelle collezioni Schuhkin e Hermitage. E artista residente alla Stanford University. Produce vari disegni per esposizioni alla Stanford University e alla galleria Paul Kantor. Mostra retrospettiva alla Washington Gallery of Modern Art di Washington D.C. Nessun dipinto porta la data di quest'anno.

1966 Vede l'importante retrospettiva di Matisse al Los Angeles County Museum of Art. Si trasferisce nella California meridionale; affitta uno studio nella sezione Ocean Park di Santa Monica. E Professore di Arte della Università della California a Los Angeles fino al 1973.

1967 Inizia grandi dipinti astratti, la serie *Ocean Park* che continua tuttora.

1968 Prima mostra dei dipinti *Ocean Park* alla galleria Poindexter. Riceve il premio medaglia d'oro Carol H. Beck all'Accademia di Belle Arti della Pennsylvania a Filadelfia. Espone alla trentaquattresima Biennale di Venezia. Subisce un'operazione alla schiena.

1969- I dipinti *Ocean Park* sono ampiamente esposti. Mostre perso-
1971 nali al Los Angeles County Museum of Art e alla galleria Poindexter. Mostra personale alla galleria Marlborough di New York.

1972- Mostra personale alla galleria Marlborough di Londra e alla
1975 galleria Marlborough di New York. Grande mostra di dipinti *Ocean Park* al Museum of Art di San Francisco. Altre numerose mostre personali e collettive.

1976 Mostra di monotipi UCLA. Importante retrospettiva alla Albright-Knox Art Gallery di Buffalo, New York, mostra itinerante attraverso gli Stati Uniti.

Bibliography

Selected Bibliography: Articles and Reviews (arranged chronologically)

Langsner, Jules. "Art News from Los Angeles: Diebenkorn, Randall." *Art News* (New York), vol. 51, no. 7, Nov. 1952, p. 61.

Langsner, Jules. "Art News from Los Angeles: Diebenkorn, Heerman." *Art News* (New York), vol. 53, no. 3, May 1954, p. 47.

Whiteside, Forbes. "Three Young Americans." *Allen Memorial Art Museum Bulletin, Oberlin College* (Oberlin, Ohio), vol. 12, no. 3, Spring 1955, pp. 91-97.

Ashton, Dore. "Young Painters in Rome." *Arts Digest* (New York), vol. 29, no. 17, June 1, 1955, pp. 6-7.

S[awin], M[artica]. "Month in Review, Poindexter Group." *Arts Digest* (New York), vol. 29, no. 20, Sept. 15, 1955, p. 2.

R. R. "In the Galleries: Richard Diebenkorn." *Arts* (New York), vol. 30, no. 6, Mar. 1956, p. 56.

T[yler], P[arker]. "Reviews and Previews: Richard Diebenkorn." *Art News* (New York), vol. 55, no. 1, Mar. 1956, p. 51.

Ashton, Dore. "Art." *Arts and Architecture* (Los Angeles), vol. 73, Apr. 1956, p. 11.

Chipp, Herschel B. "Diebenkorn Paints a Picture." *Art News* (New York), vol. 56, no. 3, May 1957, pp. 44-47, 54-55.

"Look of the West Inspires New Art." *Life* (New York), vol. 43, no. 19, Nov. 4, 1957, pp. 65-69.

"Figurative Painters in California." *Arts* (New York), vol. 32, no. 3, Dec. 1957, pp. 26-27.

Ashton, Dore. "Art: Rebel in the West." *The New York Times,* Feb. 25, 1958, p. 55.

Grissom, Sarah. "San Francisco." *Arts* (New York), vol. 32, no. 5, Feb. 1958, p. 22.

"Edging Away from Abstraction." *Time* (New York), vol. 71, no. 11, Mar. 17, 1958, p. 64.

V[entura], A[nita]. "In the Galleries: Richard Diebenkorn." *Arts* (New York), vol. 32, no. 6, Mar. 1958, p. 56.

C[ampbell], L[awrence]. "Reviews and Previews: Richard Diebenkorn." *Art News* (New York), vol. 57, no. 1, Mar. 1958, p. 13.

Ashton, Dore. "Art." *Arts and Architecture* (Los Angeles), vol. 75, May 1958, p. 29.

Johnson, E[llen]. "Diebenkorn's *Woman by a Large Window.*" *Allen Memorial Art Museum Bulletin, Oberlin College* (Oberlin, Ohio), vol. 16, no. 1, Fall 1958, pp. 18-23.

Alloway, Lawrence. "London Chronicle." *Art International* (Zurich), vol. 2, nos. 9-10, Dec. 1958–Jan. 1959, pp. 33-36, 101.

Temko, Allan. "The Flowering of San Francisco." *Horizon* (New York), vol. 1, no. 3, Jan. 1959, pp. 13-15.

Lanes, Jerrold. "Brief Treatise on Surplus Value or, The Man Who Wasn't There." *Arts* (New York), vol. 34, no. 2, Nov. 1959, pp. 29-35.

M[unro], E[leanor] C. "Reviews and Previews: Four Landscape Painters." *Art News* (New York), vol. 59, no. 3, May 1960, p. 15.

Richardson, John. "The Neuberger Collection." *Art in America* (New York), vol. 48, no. 2, Summer 1960, pp. 87-88.

Munro, Eleanor C. "Figures to the Fore." *Horizon* (New York), vol. 2, no. 6, July 1960, pp. 16-24; 114-116.

S[awin], M[artica]. "In the Galleries: Park, Bischoff, Diebenkorn." *Arts* (New York), vol. 35, no. 3, Dec. 1960, p. 50.

S[andler], I[rving] H. "Reviews and Previews: Elmer Bischoff, Richard Diebenkorn and David Park." *Art News* (New York), vol. 59, no. 8, Dec. 1960, p. 15.

Chipp, Herschel B. "Art News from San Francisco." *Art News* (New York), vol. 59, no. 10, Feb. 1961, p. 54.

P[eterson], V[alerie]. "Reviews and Previews: Richard Diebenkorn." *Art News* (New York), vol. 60, no. 1, Mar. 1961, p. 13.

Tillim, Sidney. "Month in Review." *Arts* (New York), vol. 35, no. 7, Apr. 1961, pp. 47-48.

Sandler, Irving Herschel. "New York Letter." *Art International* (Zurich), vol. 5, no. 4, May 1, 1961, pp. 52-54.

Kramer, Hilton. "The Latest Thing in Pittsburgh." *Arts Magazine* (New York), vol. 36, no. 4, Jan. 1962, pp. 24-27.

"Human Figure Returns in Separate Ways and Places." *Life* (New York), vol. 52, no. 23, June 8, 1962, pp. 54-61.

Greenberg, Clement. "After Abstract Expressionism." *Art International* (Zurich), vol. 6, no. 8, Oct. 25, 1962, pp. 24-32.

Langsner, Jules. "Los Angeles Letter." *Art International* (Zurich), vol. 6, no. 10, Dec. 20, 1962, pp. 38-40.

Ashton, Dore. "West Coast Artists Score in Painting." *Studio* (New York), vol. 165, no. 838, Feb. 1963, pp. 64-67.

Wight, Frederick. "The Phillips Collection–Diebenkorn, Woelffer, Mullican: A Discussion." *Artforum* (New York), vol. 1, no. 10, Apr. 1963, pp. 23-28.

Coplans, John. "Notes from San Francisco." *Art International* (Zurich), vol. 7, no. 5, May 25, 1963, p. 73.

Van Der Marck, Jan. "The Californians." *Art International* (Zurich), vol. 7, no. 5, May 25, 1963, pp. 28-31.

M[onte], J[ames]. "Reviews: Drawings by Elmer Bischoff, Richard Diebenkorn and Frank Lobdell." *Artforum* (New York), vol. 2, no. 1, July 1963, pp. 7-8.

Ventura, Anita. "The Prospect over the Bay." *Arts Magazine* (New York), vol. 37, no. 9, May-June 1963, pp. 19-21.

Leider, Philip. "California–After the Figure." *Art in America* (New York), vol. 51, no. 5, Oct. 1963, pp. 73-83.

M[onte], J[ames]. "Reviews: Richard Diebenkorn, DeYoung Museum." *Artforum* (New York) vol. 2, no. 5, Nov. 1963, p.43.

P[etersen], V[alerie]. "Reviews and Previews: Richard Diebenkorn." *Art News* (New York), vol. 62, no. 8, Dec. 1963, p. 54.

Kramer, Hilton. "Pure and Impure Diebenkorn." *Arts Magazine* (New York), vol. 38, no. 3, Dec. 1963, pp. 46-53.

Magloff, Joanna. "Art News from San Francisco." *Art News* (New York), vol. 62, no. 9, Jan. 1964, pp. 51-52.

Rapp, Lita. "Redwood City, Calif.—Letter to Editor about Kramer's Article of December 1963." *Arts Magazine* (New York), vol. 38, no. 5, Feb. 1964, p. 6.

Leider, Philip. "Diebenkorn Drawings at Stanford." *Artforum* (New York), vol. 2, no. 11, May 1964, pp. 41-42.

Coplans, John. "Circle of Styles on the West Coast." *Art in America* (New York), vol. 52, no. 3, June 1964, pp. 24-41.

Mills, Paul. "Bay Area Figurative." *Art in America* (New York), vol. 52, no. 3, June 1964, pp. 42-45.

Gosling, Nigel. "A New Realist." *The Observer* (London), Oct. 4, 1964, p. 25.

Wallis, Nevile. "Round the London Galleries Autumn Flowering." *Apollo* (London), vol. LXXX, no. 32, Oct. 1964, p. 324.

O'Doherty, Brian. "Ethics of Adversity." *Newsweek* (New York), Nov. 30, 1964, p. 97.

Getlein, Frank. "Two Privacies." *New Republic* (New York), vol. 151, no. 23, Dec. 5, 1964, pp. 25-26.

Whittet, G. S. "Figurative Abstraction—or abstracted figuration?— London Commentary." *Studio International* (London), vol. 168, no. 860, Dec. 1964, pp. 272-275.

Nordland, Gerald. "Richard Diebenkorn." *Artforum* (New York), vol. 3, no. 4, Jan. 1965, pp. 21-25.

C[ampbell], L[awrence]. "Reviews and Previews: Richard Diebenkorn." *Art News* (New York), vol. 64, no. 1, Mar. 1965, p. 12.

R[aynor], V[ivien]. "In the Galleries: Richard Diebenkorn." *Arts Magazine* (New York), vol. 39, no. 6, Mar. 1965, p. 54.

Kaufman, B. "Diebenkorn." *Commonweal* (New York), Mar. 5, 1965, pp. 755-56.

Ventura, Anita. "San Francisco: The Aloof Community." *Arts Magazine* (New York), vol. 39, no. 7, Apr. 1965, pp. 70-73.

Kramer, Hilton. "The Diebenkorn Case." *The New York Times,* May 22, 1966, p. 29.

Kramer, Hilton. "Art Mailbag—Concerning the Diebenkorn Case." *The New York Times,* June 12, 1966, p. 22.

Lucie-Smith, Edward. "The Primitive and Exotic—London Commentary." *Studio International* (London), vol. 173, no. 885, Jan. 1967, p. 39.

Kramer, Hilton. "Richard Diebenkorn." *The New York Times,* Nov. 15, 1967, p. 31.

Canaday, John. "Richard Diebenkorn: Still Out of Step." *The New York Times,* May 26, 1968, p. 37.

Feldman, Anita. "The Figurative, the Literary, the Literal: American Figurative Tradition at the Venice Biennale." *Arts Magazine* (New York), vol. 42, no. 8, June/Summer 1968, pp. 22-27.

N[ewman], R[obert]. "In the Galleries: Richard Diebenkorn." *Arts Magazine* (New York), vol. 42, no. 8, June/Summer 1968, p. 60.

C[ampbell], L[awrence]. "Reviews and Previews: Richard Diebenkorn." *Art News* (New York), vol. 67, no. 4, Summer 1968, p. 14.

Kramer, Hilton. "Diebenkorn Marries Skill to Feeling." *The New York Times,* Jan. 4, 1969, p. 23.

L[ast], M[artin]. "Reviews and Previews: Richard Diebenkorn." *Art News* (New York), vol. 67, no. 10, Feb. 1969, p. 13.

Tillim, Sidney. "The Reception of Figurative Art: Notes on a General Misunderstanding." *Artforum* (New York), vol. 7, no. 6, Feb. 1969, pp. 30-33.

Mellow, James R. "New York Letter." *Art International* (Lugano), vol. 13, no. 3, Mar. 20, 1969, pp. 56-60.

Glueck, Grace. "Open Season, New York Gallery Notes." *Art in America* (New York), vol. 57, no. 5, Sept.—Oct. 1969, pp. 116-120.

Garver, Thomas H. "Los Angeles: Richard Diebenkorn, Los Angeles County Museum." *Artforum* (New York), vol. 8, no. 1, Sept. 1969, p. 66.

E[dgar], N[atalie]. "Reviews and Previews: Richard Diebenkorn." *Art News* (New York), vol. 68, no. 7, Nov. 1969, p. 14.

A. "In the Galleries: Richard Diebenkorn." *Arts Magazine* (New York), vol. 44, no. 3, Dec. 1969—Jan. 1970, p. 64.

Baker, Kenneth. "Ocean Park Series." *The Christian Science Monitor* (Boston), Jan. 14, 1970, p. 8.

Diebenkorn, Richard. "Ocean Park, #24." *Art Now: New York* (New York), vol. 2, no. 1, Jan. 1970, n.p.

Fenton, Terry. "New York." *Artforum* (New York), vol. 8, no. 5, Jan. 1970, pp. 64-65.

Ratcliff, Carter. "New York Letter." *Art International* (Lugano), vol. 14, no. 1, Jan. 20, 1970, pp. 96-97.

Plagens, Peter. "Los Angeles." *Artforum* (New York), vol. 9, no. 8, Apr. 1971, p. 84.

E[dgar], N[atalie]. "Reviews and Previews: Richard Diebenkorn." *Art News* (New York), vol. 70, no. 2, Apr. 1971, p. 10.

Baker, Kenneth. "New York." *Artforum* (New York), vol. 9, no. 9, May 1971, pp. 74-75.

Shirey, David L. "From Diebenkorn, Exhilarating Show." *The New York Times,* Dec. 4, 1971, p. 27.

Davis, Douglas. "Gallery Hopping in New York." *Newsweek* (New York), Dec. 27, 1971, pp. 36-37.

R[osenstein], H[arris]. "Reviews and Previews: Richard Dieben-korn." *Art News* (New York), vol. 70, no. 8, Dec. 1971, p. 14.

Ashton, Dore. "Richard Diebenkorn's Paintings." *Arts Magazine* (New York), vol. 46, no. 3, Dec. 1971–Jan. 1972, pp. 35-37.

Elderfield, John. "Diebenkorn at Ocean Park." *Art International* (Lugano), vol. 16, no. 2, Feb. 20, 1972, pp. 20-25.

Lanes, Jerrold. "Richard Diebenkorn: Cloudy Skies over Ocean Park." *Artforum* (New York), vol. 10, no. 6, Feb. 1972, pp. 61-63.

Ratcliff, Carter. "New York Letter." *Art International* (Lugano), vol. 16, no. 2, Feb. 26, 1972, p. 52.

Wolmer, Denise. "In the Galleries: Diebenkorn–Marlborough." *Arts Magazine* (New York), vol. 46, no. 4, Feb. 1972, p. 58.

Kramer, Hilton. "The Return of 'Handmade' Painting." *The New York Times,* Apr. 30, 1972, p. 23.

McCann, Cecilie N. "The Ocean Park Series." *Artweek* (Oakland, Calif.), vol. 3, no. 35, Oct. 21, 1972, p. 7.

Mills, Paul C. "Richard Diebenkorn: Painting Against the Tide." *Saturday Review of the Arts* (San Francisco), vol. 55, no. 45, Nov. 1972, pp. 55-59.

Dunham, Judith L. "A Period of Exploration." *Artweek* (Oakland, Calif.), vol. 4, no. 30, Sept. 15, 1973, pp. 1, 15.

Buri, James. "Round the Galleries. Every Wrinkle, Crease and Flaw." *Apollo* (London), vol. XCVIII, no. 142, Dec. 1973, p. 506.

Plagens, Peter. "Reviews." *Artforum* (New York), vol. 12, no. 4, Dec. 1973, pp. 91-92.

Wright, Barbara. "Diebenkorn." *Arts Review* (London), vol. 25, no. 25, Dec. 15, 1973, p. 867.

Marle, Judy. "UK Reviews Richard Diebenkorn." *Studio International* (London), vol. 187, no. 962, Jan. 1974, p. 39.

Denvir, Bernard. "London Letter." *Art International* (Lugano), vol. 18, no. 2, Feb. 20, 1974, p. 33.

"Statements: Richard Diebenkorn." *Studio International* (London), vol. 188, no. 968, July-Aug. 1974, p. 14.

Wilson, William. "Diebenkorn at Corcoran Gallery." *Los Angeles Times,* Feb. 17, 1975, p. 5.

Gresen, Sara. "Richard Diebenkorn: Before and Behind the Eye." *Arts Magazine* (New York), vol. 49, no. 10, June 1975, pp. 79-81.

Albright, Thomas. "The Nation San Francisco: Spin-Off." *Art News* (New York), vol. 74, no. 6, Summer 1975, pp. 113-114.

Perrone, Jeff. "Reviews." *Artforum* (New York), vol. 13, no. 10, Summer 1975, p. 79.

Marmer, Nancy. "Los Angeles: Richard Diebenkorn at James Corcoran." *Art in America* (New York), vol. 63, no. 4, July-Aug. 1975, p. 110.

Russell, John. "The Radiance in Diebenkorn Paintings." *The New York Times,* Dec. 6, 1975, p. 25.

Kingsley, April. "Ocean Park is Dead." *The SoHo Weekly News* (New York), Dec. 25, 1975, p. 18.

Ratcliff, Carter. "New York Letter." *Art International* (Lugano), vol. 20, nos. 2-3, Feb.-Mar. 1976, pp. 37-40.

Hazlett, Gordon J. "An Incredibly Beautiful Quandary." *Art News* (New York), vol. 75, no. 5, May 1976, pp. 36-38.

Zalkind, Simon. "Richard Diebenkorn, Stephen Edlich, Robert Motherwell." *Arts Magazine* (New York), vol. 51, no. 1, Sept. 1976, p. 9.

Brown, Gordon. "Robert Motherwell/Richard Diebenkorn/Stephen Edlich." *Arts Magazine* (New York), vol. 51, no. 3, Nov. 1976, p. 18.

Simon, Jeff. "Uncommon Concern for Truth in Art as shown by Diebenkorn." *Buffalo Evening News,* Nov. 16, 1976, p. 69.

Bannon, Anthony. "Diebenkorn Art Defies Search for Conformity." *Buffalo Evening News,* Nov. 17, 1976, p. 70.

Russell, John. "Diebenkorn's Shining Achievement." *The New York Times,* Dec. 5, 1976, p. 33.

Cavaliere, Barbara. "Three Generations of American Painting." *Arts Magazine* (New York), vol. 51, no. 4, Dec. 1976, p. 38.

Perrone, Jeff. "Reviews." *Artforum* (New York), vol. 15, no. 4, Dec. 1976, pp. 73-74.

Hazlett, Gordon J. "Problem Solving in Solitude." *Art News* (New York), vol. 76, no. 1, Jan. 1977, pp. 76-79.

Kingsley, April. "Real Alternatives: Richard Diebenkorn and Stephen Greene." *The SoHo Weekly News* (New York), Jan. 20, 1977, pp. 20, 25.

Findser, Owen. "Diebenkorn: A Rebel Against Rebellion." *The Cincinnati Enquirer,* Feb. 6, 1977, p. F6.

Tuchman, Maurice. "Richard Diebenkorn: The Early Years." *Art Journal* (New York), Spring 1977, pp. 206-20.

Hopkins, Budd. "Diebenkorn Reconsidered." *Artforum* (New York), vol. 15, no. 7, Mar. 1977, pp. 37-41.

Lewis, JoAnn. "Diebenkorn: Growth of an Artist." *The Washington Post,* Apr. 16, 1977, pp. B1, B4.

Forgey, Benjamin. "Three Different Diebenkorns." *The Washington Star,* Apr. 17, 1977, pp. 20-21.

Glueck, Grace. "Swirl of the Golden West." *The New York Times,* June 10, 1977, p. 20.

Tallmer, Jerry. "Diebenkorn: Painter Against the Grain." *New York Post,* June 11, 1977, p. 20.

Kramer, Hilton. "Diebenkorn's Mastery." *The New York Times,* June 12, 1977, p. 25.

Kramer, Hilton. "Diebenkorn Show Organized Here, Hit in Gotham." *Courier Express* (Buffalo), June 12, 1977, p. 32.

Stevens, Mark. "Amazing Grace." *Newsweek* (New York), June 20, 1977, pp. 83-85.

Zimmer, William. "Diebenkorn: Conquered Territories." *The SoHo Weekly News* (New York), June 23, 1977, p. 20.

Olson, Roberta J. M. "Thus Spake Diebenkorn." *The SoHo Weekly News* (New York), June 23, 1977, pp. 20, 47.

Hughes, Robert. "California in Eupeptic Color." *Time* (New York), June 27, 1977, p. 58.

Bourdon, David. "In the Realm of Sensuous Color." *Village Voice* (New York), June 27, 1977, p. 85.

Raynor, Vivien. "Diebenkorn's Shifting Styles." *The New Leader* (New York), vol. 60, no. 15, July 18, 1977, pp. 25-26.

Seldis, Henry J. "A Look at Diebenkorn, Past and Present." *Los Angeles Times,* Aug. 7, 1977, pp. 18-19.

Ianko-Starrels, Josine. "30 Years of Diebenkorn." *Los Angeles Times,* Aug. 7, 1977, p. 83.

Seldis, Henry J. "Diebenkorn's Triumphant Retrospective." *Los Angeles Times,* Aug. 21, 1977, pp. 1, 78-79.

Larsen, Susan C. "Richard Diebenkorn's Retrospective." *Artweek* (Oakland, Calif.), vol. 8, no. 28, Aug. 27, 1977, pp. 1, 20.

Busche, Ernest. "Richard Diebenkorn." *Das Kuntswerk* (Stuttgart), vol. 30, no. 5, Oct. 1977, pp. 43-44.

Coffelt, Beth. "Doomsday in the Bright Sun." *San Francisco Sunday Examiner & Chronicle,* Oct. 16, 1977, pp. 22-28.

Shere, Charles. "The Geometry of Richard Diebenkorn." *Oakland Tribune* (Oakland, Calif.), Oct. 16, 1977, pp. 1-E, 20-E.

Marmer, Nancy. "Richard Diebenkorn: Pacific Extensions." *Art in America* (New York), vol. 66, no. 1, Jan.-Feb. 1978, pp. 95-99.

Exhibitions

Selected Group Exhibitions and Catalogues
(arranged chronologically)

1948 Los Angeles, California, Los Angeles County Museum of Art, *California Centennial Exhibition.*

San Francisco, California, San Francisco Museum of Art. *Sixty-Seventh Annual Exhibition.*

1949 San Francisco, California, Lucien Labaudt Gallery. (with *Hassel Smith*)

1951 Los Angeles, California, Los Angeles County Museum of Art. *Contemporary Painting in the U.S.*

1953 Los Angeles, California, Paul Kantor Gallery. *Contemporary Paintings.*

1954 Colorado Springs, Colorado, Colorado Springs Fine Arts Center. *New Accessions USA.* Cat. text by James B. Byrnes.

New York, New York, The Solomon R. Guggenheim Museum. *Younger American Painters.* Cat. text by James Johnson Sweeney.

1955 Champaign-Urbana, Illinois, University of Illinois. *Contemporary American Painting and Sculpture.*

Minneapolis, Minnesota, Walker Art Center. *Vanguard 1955.* Cat. text by Kyle Morris.

New York, New York, Poindexter Gallery. *Contemporary Arts.*

New York, New York, Whitney Museum of American Art. *1955 Annual Exhibition of Contemporary American Painting.*

Oberlin, Ohio, Allen Memorial Art Museum, Oberlin College. *Three Young Americans: Glasco, McCullough, Diebenkorn.* Check list in *Allen Memorial Art Museum Bulletin, Oberlin College* (Oberlin, Ohio) vol. 12, no. 3, Spring 1955, pp. 91-97.

Pittsburgh, Pennsylvania, Department of Fine Arts, Carnegie Institute. *The 1955 Pittsburgh International Exhibition of Contemporary Painting.* Cat. text by Gordon Bailey Washburn.

Rome, Italy, Congress for Cultural Freedom. *Young Painters.* Traveled to Brussels.

São Paulo, Brazil. *III Bienal International de São Paulo.*

Washington, D.C., The Corcoran Gallery of Art. *24th Biennial.*

1956 San Francisco, California, San Francisco Museum of Art. *2nd Pacific Coast Biennial.*

1957 Boston, Massachusetts, Swetzoff Gallery. *Richard Diebenkorn—Paintings; Kenneth Armitage—Sculpture.*

Chicago, Illinois, The Art Institute of Chicago. *LXII American Exhibition: Paintings/Sculpture.*

Los Angeles, California, Ferus Gallery. *Objects in the New Landscape Demanding of the Eye.*

Minneapolis, Minnesota, The Minneapolis Institute of Arts. *American Paintings 1945-1957.* Cat. text by Stanton L. Catlin.

New York, New York, Knoedler & Co. *Modern Painting, Drawing and Sculpture Collected by Louise and Joseph Pulitzer, Jr.* Cat. text by Charles Scott Chetham. Traveled to Cambridge, Massachusetts, Fogg Art Museum.

Oakland, California, The Oakland Art Museum. *Contemporary Bay Area Figurative Painting.* Cat. text by Paul Mills. Traveled to Los Angeles, California, Los Angeles County Museum of Art; Dayton, Ohio, Dayton Art Institute.

1958 Brussels, Belgium, Brussels Universal and International Exhibition (World's Fair), American Pavilion. *Seventeen Contemporary American Artists and Eight Sculptors.* Cat. texts by Grace L. McCann Morley and George W. Staempfli. Traveled to London, England, USIS Library.

New York, New York, Whitney Museum of American Art. *Annual Exhibition.*

New York, New York, World House Gallery. *Brussels '58.* Cat. text by Harris K. Prior.

Pittsburgh, Pennsylvania, Department of Fine Arts, Carnegie Institute. *The 1958 Pittsburgh Bicentennial International Exhibition of Contemporary Painting and Sculpture.* Cat. text by Gordon Bailey Washburn.

Richmond, Virginia, The Virginia Museum of Fine Arts. *American Painting 1958.* Cat. text by Grace L. McCann Morley.

1959 Bloomington, Indiana, Indiana University Art Museum. *New Imagery in American Painting.*

Buffalo, New York, Albright-Knox Art Gallery. *Contemporary Art-Acquisitions 1957-58.*

Kansas City, Missouri, William Rockhill Nelson Gallery and Atkins Museum of Fine Arts. *Aspects of Representation in Contemporary Art.*

Los Angeles, California, Dilexi Gallery, *1st Anniversary Group Show.*

New York, New York, The Museum of Modern Art. *New Images of Man.* Cat. text by Peter Selz; statements by the artists.

Tallahassee, Florida, Florida State University Gallery. *New Directions in Painting.* Cat. text by James V. McDonough. Traveled to Sarasota, Florida, John and Mabel Ringling Museum of Art; West Palm Beach, Florida, Norton Gallery and School of Art.

Washington, D.C., The Corcoran Gallery of Art. *26th Annual.*

1960 Boston, Massachusetts, Institute of Contemporary Art. *The Image Lost and Found.*

Darmstadt, Germany, Hessisches Landesmuseum. *Moderne Amerikanische Malerei: 1930-1958* (organized by City Art Museum, St. Louis, Missouri for U.S. Information Agency). Cat. text by Dorothy Adlow. Traveled to Goteborg, Sweden, Göteborgs Konstmuseum as *Modernt Amerikanskt Maleri: 1932-1958.*

New York, New York, Knoedler & Co. *American Art, 1910-1960. Selections from the Collection of Mr. and Mrs. Roy R. Neuberger.*

New York, New York, Poindexter Gallery. *Landscapists.*

New York, New York, Staempfli Gallery. *Elmer Bischoff, Richard Diebenkorn, David Park.*

Utica, New York, Munson-Williams-Proctor Institute. *Art Across America.*

1961 Champaign-Urbana, Illinois, Krannert Art Museum, University of Illinois. *Contemporary American Painting and Sculpture.*

Iowa City, Iowa, State University of Iowa. *Main Currents of Contemporary Painting.* Cat. text by Frank Seiberling.

New York, New York, American Federation of the Arts. *The Figure in Contemporary American Painting.*

Pittsburgh, Pennsylvania, Department of Fine Arts, Carnegie Institute. *The 1961 Pittsburgh International Exhibition of Contemporary Painting and Sculpture.* Cat. text by Gordon Bailey Washburn.

San Francisco, California, California Palace of the Legion of Honor. *Third Winter Invitational Exhibition.* Cat. text by Howard Ross Smith.

Santa Barbara; California, Santa Barbara Museum of Art. *Two Hundred Years of American Painting 1755-1960.* Cat. text by E. Maurice Bloch.

São Paulo, Brazil. *VI Bienal International de São Paulo.*

Washington, D.C., The Corcoran Gallery of Art. *27th Annual.*

1962 Fort Worth, Texas, Amon Carter Museum of Western Art. *The Artist's Environment: West Coast.* [In collaboration with the UCLA Art Galleries and The Oakland Art Museum]. Cat. text by Frederick S. Wight. Traveled to Los Angeles, California, University of California at Los Angeles Art Galleries; Oakland, California, The Oakland Art Museum.

London, England, Gimpel Fils. *Selection of East Coast and West Coast American Painters.*

London, England, Embassy Building. *Vanguard American Painting.*

Los Angeles, California, University of California at Los Angeles Art Galleries. *Lithographs from the Tamarind Workshop.* Cat. text by Frederick S. Wight.

Los Angeles, California, University of California at Los Angeles Art Galleries. *The Gifford and Joann Phillips Collection.* Cat. text by Gifford Phillips.

Milwaukee, Wisconsin, Milwaukee Art Center. *Art U.S.A.: Now.* Traveled throughout Europe and the United States.

New York, New York, Martha Jackson Galleries. *Selections 1934-1961, American Artists from the Collection of Martha Jackson.*

New York, New York, National Institute of Arts and Letters. *Exhibition of Contemporary Painting and Sculpture.*

New York, New York, National Institute of Arts and Letters. *Exhibition of Work by Newly Elected Members & Recipients of Honors and Awards.*

New York, New York, Whitney Museum of American Art. *Fifty California Artists.* [organized by San Francisco Museum of Art with the assistance of Los Angeles County Museum of Art]. Traveled to Minneapolis, Minnesota, Walker Art Center; Buffalo, New York, Albright-Knox Art Gallery; Des Moines, Iowa, Des Moines Art Center.

Seattle, Washington, Seattle World's Fair, Fine Arts Pavilion. *American Art Since 1950.* Cat. text by Sam Hunter. Traveled to Waltham, Massachusetts, Rose Art Museum, Brandeis University; Boston, Massachusetts, Institute of Contemporary Art.

1963 New York, New York, Whitney Museum of American Art. *Annual Exhibition 1963, Contemporary American Painting.*

Paris, France, American Cultural Center. *American Painters from A to Z.*

San Francisco, California, California Palace of the Legion of Honor. *Drawings by Bischoff, Diebenkorn, Lobdell.*

Washington, D.C., The Corcoran Gallery of Art. *28th Biennial.*

1964 Albuquerque, New Mexico, The Art Gallery, University of New Mexico. *Seventy-fifth Anniversary Alumni Exhibition.*

Bloomington, Indiana, Fine Arts Gallery, Indiana University. *American Painting 1910-1960: A Special Exhibition Celebrating the 50th Anniversary of the Association of College Unions.* Cat. text by Henry R. Hope.

Cincinnati, Ohio, Cincinnati Art Museum. *American Paintings on the Market Today II.*

Little Rock, Arkansas, Arkansas Arts Center. *Six Americans.*

London, England, Tate Gallery. [organized by the Calouste Gulbenkian Foundation]. *Painting and Sculpture of a Decade.* Cat. text unsigned.

New York, New York, The Solomon R. Guggenheim Museum. *American Drawings.* Cat. text by Lawrence Alloway.

New York, New York, Staempfli Gallery. *Seven California Painters.* Cat. text by Lawrence Alloway.

Pittsburgh, Pennsylvania, Museum of Art, Carnegie Institute. *The 1964 Pittsburgh International Exhibition of Contemporary Painting and Sculpture.* Cat. text by Gustave von Groschwitz.

Los Angeles, California, University of Southern California. Fisher and Quinn Galleries. *New Dimensions in Lithography.*

1965 Edinburgh, Scotland, Scottish National Gallery of Modern Art. *Two American Painters, Abstract and Figurative: Sam Francis, Richard Diebenkorn.* Cat. text unsigned.

New York, New York, Whitney Museum of American Art. *1965 Annual Exhibition Contemporary American Painting.*

San Antonio, Texas, Witte Memorial Museum. *Selection from the Work of California Artists.*

San Francisco, California, M.H. de Young Memorial Museum. *The San Francisco Collector.* Cat. text by Jack R. McGregor.

1966 Austin, Texas, The Art Museum, The University of Texas at Austin. *Drawings.* Cat. text by Mercedes Matter.

New York, New York, Whitney Museum of American Art. *Art of the United States 1670-1960.* Cat. text by Lloyd Goodrich.

Washington, D.C., Washington Gallery of Modern Art. *The Permanent Collection.* Cat. text by Gerald Nordland.

1967 Grand Rapids, Michigan, The Grand Rapids Art Museum. *20th Century American Painting.* Cat. text by Anne E. Warnock.

Los Angeles, California, Lytton Center of the Visual Arts. *California Art Festival.* Cat. text by Irving Stone.

New York, New York, Finch College Museum of Art. *Documentation-Sculpture, Paintings, Drawings.*

New York, New York, National Institute of Arts and Letters. *Exhibition of Work by Newly Elected Members & Recipients of Honors and Awards.*

New York, New York, Whitney Museum of American Art. *1967 Annual Exhibition of Contemporary Painting.*

Raleigh, North Carolina, North Carolina Museum of Art. *American Paintings Since 1900 from the Permanent Collection.* Cat. text by Ben F. Williams.

Rochester, Michigan, The University Art Gallery, Oakland University. *A Point of View: Selected Paintings and Drawings*

from the Richard Brown Baker Collection. Cat. text by Richard Brown Baker.

Seattle, Washington, Henry Art Gallery, University of Washington. *Drawings by Americans.* Cat. text by Gervais Reed.

1968 Austin, Texas, The Art Museum, The University of Texas at Austin. *Painting as Painting.* Cat. texts by Dore Ashton, George McNeil and Louis Finkelstein.

Lawrence, Kansas, University of Kansas Museum of Art. *Modern Art from Midwestern Collections.*

Los Angeles, California, Los Angeles County Museum of Art. *Late Fifties at the Ferus.* Cat. text by James Monte.

Norman, Oklahoma, Museum of Art, University of Oklahoma and Oklahoma City, Oklahoma, Oklahoma Art Center. *East Coast-West Coast Painters.* Cat. text by Sam Olkinetzky. Traveled to Tulsa, Oklahoma, Philbrook Art Center.

Philadelphia, Pennsylvania, Pennsylvania Academy of the Fine Arts. *163rd Annual.*

San Francisco, California, San Francisco Museum of Art. *"Untitled," 1968.* Cat. text by Wesley Chamberlain.

Venice, Italy, American Pavilion, XXXIV Esposizione Biennale Internazionale d'arte di Venezia. *The Figurative Tradition in Recent American Art.* Cat. text by Norman A. Geske. Traveled to Washington, D.C., National Collection of Fine Arts; Lincoln, Nebraska, Sheldon Memorial Art Gallery, University of Nebraska.

1969 Eindhoven, The Netherlands, Stedelijik van Abbemuseum. *Kompas VI— West Coast USA.* Cat. text by Jean Leering.

New York, New York, Whitney Museum of American Art. *1969 Annual Exhibition, Painting.*

Pasadena, California, Pasadena Art Museum. *West Coast 1945-1969.* Cat. text by John Coplans.

1970 Berkeley, California, University Art Museum, University of California. *Excellence: Art from the University Community.* Cat. text by Peter Selz.

Los Angeles, California, Crocker-Citizens National Bank. *A Century of California Painting 1870-1970.*

New York, New York, Compass Gallery. *Inner Spaces—Outer Limits.* Traveled to Clinton, New York, Vera G. and Arthur A. List Art Center, Kirkland College.

Omaha, Nebraska, Joslyn Art Museum. *Looking West 1970.* Cat. text by LeRoy Butler.

Pittsburgh, Pennsylvania, Museum of Art, Carnegie Institute. *1970 Pittsburgh International Exhibition of Contemporary Art.* Cat. text by Leon Anthony Arkus.

Santa Barbara, California, The Art Galleries, University of California. *Trends in Twentieth Century Art, A Loan Exhibition from the San Francisco Museum of Art.*

San Francisco, California, San Francisco Museum of Art. *1970 National Drawing Exhibition.* Cat. text by Gerald Nordland.

St. Paul de Vence, France, Fondation Maeght. *L'Art Vivant aux Etats-Unis.*

1971　Iowa City, Iowa, University of Iowa Museum of Art. *Accessions 1970-71.*

Lafayette, Indiana, Purdue University. *Two Directions in American Painting.*

London, England, The Arts Council of Great Britain-Hayward Gallery. *11 Los Angeles Artists.* Cat. text by Maurice Tuchman and Jane Livingston.

Los Angeles, California, Grunwald Graphic Arts Foundation, Dickson Art Center, University of California at Los Angeles. *Made in California.* Cat. texts by Kathryn A. Smith and Francis Martin.

Stanford, California, Stanford University Museum. *Stanford Collects.*

Stanford, California, Stanford University Museum. *A Decade in the West.* Cat. text by Albert E. Elsen. Traveled to Santa Barbara, California, Santa Barbara Museum of Art.

1972　Boston, Massachusetts, Museum of Fine Arts. *Abstract Painting in the '70's: A Selection.* Cat. text by Kenworth Moffett.

Chicago, Illinois, The Art Institute of Chicago. *Seventieth American Exhibition.*

New York, New York, Whitney Museum of American Art. *1972 Annual American Exhibition, Contemporary American Painting.*

New York, New York, ACA Galleries. *Looking West.* Cat. text by Andrew J. Crispo.

San Francisco, California, San Francisco Art Institute. *Crown Point Press at the San Francisco Art Institute.* Cat. text by Kathan Brown.

1973　College Park, Maryland, University of Maryland Art Gallery. *Mixed Bag.*

College Park, Maryland, University of Maryland Art Gallery. *The Private Collection of Martha Jackson.* Cat. text by Elayne H. Varian. Traveled to New York, New York, Finch College Museum of Art; Buffalo, New York, Albright-Knox Art Gallery.

Des Moines, Iowa, Des Moines Art Center. *Twenty-five Years of American Painting.* Cat. text by Max Kozloff.

Mason City, Iowa, Charles H. MacNider Museum. *American Artists: An Invitational.*

New Haven, Connecticut, Yale University Art Gallery. *American Drawing 1970-73.*

New York, New York, Whitney Museum of American Art. *American Drawings 1963-1973.* Cat. text by Elke M. Solomon.

Omaha, Nebraska, Joslyn Art Museum and Lincoln, Nebraska, Sheldon Memorial Art Gallery. *A Sense of Place.*

Washington, D.C., The Corcoran Gallery of Art. *33rd Biennial of Contemporary American Painting.*

1974　Champaign-Urbana, Illinois, Krannert Art Museum, University of Illinois. *Contemporary American Painting and Sculpture 1974.* Cat. texts by James R. Shipley and Allen S. Weller.

Colorado Springs, Colorado, Colorado Springs Fine Arts Center. *New Accessions USA.*

Fort Worth, Texas, Fort Worth Art Museum. *Twentieth Century Art from Fort Worth and Dallas Collections.* Cat. text by Henry T. Hopkins.

Richmond, Virginia, Virginia Museum of Fine Arts. *Twelve American Painters.* Cat. text by William Gaines.

Santa Barbara, California, Santa Barbara Museum of Art. *Fifteen Abstract Artists.* Cat. text by Ronald A. Kuchta.

1975　Albany, New York, University Art Gallery, State University of New York at Albany. *Selections from the Martha Jackson Gallery Collection.* Cat. text by David Anderson.

Arlington, Texas, University of Texas. *Figure and Field in America.* Cat. text by David Merrill.

Buffalo, New York, Albright-Knox Art Gallery. *The Martha Jackson Collection at the Albright-Knox Art Gallery.* Cat. text by Linda L. Cathcart.

Memphis, Tennessee, Brooks Memorial Art Gallery. *An Evolution of American Works.*

Oakland, California, The Oakland Museum. *California Landscape, a Metaview.*

Philadelphia, Pennsylvania, Pennsylvania Academy of the Fine Arts. *Young America.* Cat. texts by Richard J. Boyle and Louise W. Lippincott.

Washington, D.C., The Corcoran Gallery of Art. *34th Biennial of Contemporary American Painting.*

1976　Buffalo, New York, Albright-Knox Art Gallery. *Heritage and Horizon: American Painting 1776-1976.* [organized by The Toledo Museum of Art, Toledo, Ohio]. Traveled to Detroit, Michigan, The Detroit Institute of Arts; Toledo, Ohio, The Toledo Museum of Art; Cleveland, Ohio, The Cleveland Museum of Art.

Chicago, Illinois, The Art Institute of Chicago. *Seventy-second American Exhibition.* Cat. texts by Anne Rorimer and A. James Speyer.

La Jolla, California, La Jolla Museum of Contemporary Art. *Paintings from the Collection of Mr. and Mrs. Max Zurier.*

Newport Harbor, California, Newport Harbor Art Museum. *The Last Time I Saw Ferus.* Cat. text by Betty Turnbull.

New York, New York, Gruenebaum Gallery, Ltd. and Gimpel & Weitzenhoffer, Ltd. *Three Generations of American Painting: Motherwell, Diebenkorn, Edlich.* Cat. text by Jeffrey Hoffeld.

New York, New York, The Solomon R. Guggenheim Museum. *Acquisition Priorities: Aspects of Postwar Painting in America.* Cat. text by Thomas M. Messer.

1977 Pasadena, California, Baxter Art Gallery, California Institute of Technology. *Watercolors and Related Media by Contemporary Californians.* Cat. text by Michael Smith.

Tucson, Arizona, The Museum of Art at The University of Arizona. *Vault Show I.*

1978 Los Angeles, California, Margo Leavin Gallery. *Three Generations: Studies in Collage.*

San Francisco, California, John Berggruen Gallery. *Western Art.*

Walnut Creek, California, Walnut Creek Civic Arts Gallery. *Fine Art Presses.*

Exhibitions

One-Artist Exhibitions and Catalogues
(arranged chronologically)

1948 San Francisco, California, California Palace of the Legion of Honor.

1951 Albuquerque, New Mexico, University of New Mexico. *Master Thesis Exhibition.*

1952 Los Angeles, California, Paul Kantor Gallery. *An Exhibition of Paintings and Drawings by Richard Diebenkorn.* Nov. 10-Dec. 6. No cat.

1954 Chicago, Illinois, Allan Frumkin Gallery.

 Los Angeles, California, Paul Kantor Gallery. *An Exhibition of Paintings and Drawings by Richard Diebenkorn.* March. No cat.

1956 New York, New York, Poindexter Gallery. *Diebenkorn.* Feb. 28-Mar. 24. Checklist.

 Oakland, California, Oakland Art Museum. *Richard Diebenkorn.* Sept. 8-30. No cat.

1958 New York, New York, Poindexter Gallery. *Recent Paintings: Richard Diebenkorn.* Feb. 24-Mar. 22. No cat.

1960 Pasadena, California, Pasadena Art Museum. *Richard Diebenkorn.* Sept. 6-Oct. 6. Cat. introduction by Thomas W. Leavitt.

 San Francisco, California, California Palace of the Legion of Honor. *Recent Paintings by Richard Diebenkorn.* Oct. 22-Nov. 27. Cat. introduction by Howard Ross Smith.

1961 New York, New York, Poindexter Gallery. *Diebenkorn.* Mar. 13-Apr. 8. No cat.

 Washington, D.C., The Phillips Collection. *Richard Diebenkorn.* May 19-June 26. Cat. text by Gifford Phillips.

1963 San Francisco, California, M. H. de Young Memorial Museum. *Richard Diebenkorn: Paintings 1961-1963.* Sept. 7-Oct. 13. No cat.

 New York, New York, Poindexter Gallery. *Richard Diebenkorn, Recent Paintings.* Oct. 29-Nov. 16. No cat.

1964 Palo Alto, California, Stanford University Art Gallery. *Drawings by Richard Diebenkorn.* Apr. 3-26. *Drawings by Richard Diebenkorn* published after the exhibition. Text by Lorenz Eitner. (Palo Alto, California: The University Press, 1965.)

 London, England, Waddington Galleries. *Richard Diebenkorn.* Sept. 29-Oct. 24. Illustrated brochure.

 Washington, D.C., Washington Gallery of Modern Art. *Richard Diebenkorn.* Nov. 6-Dec. 31. Cat. text by Gerald Nordland. Traveled to New York, New York, The Jewish Museum, Jan. 13-Feb. 21, 1965; Newport Beach, California, Pavilion Gallery, Mar. 14-Apr. 15, 1965.

1965 Los Angeles, California, Paul Kantor Gallery. *Recent Drawings by Richard Diebenkorn.* Oct. 1-31. No cat.

1966 New York, New York, Poindexter Gallery. *Drawings by Richard Diebenkorn.* May 17-June 4. No cat.

1967 Palo Alto, California, Stanford University Art Gallery.

 London, England, Waddington Galleries. *Works on Paper.*

 Philadelphia, Pennsylvania, Pennsylvania Academy of the Fine Arts. *Drawings by Richard Diebenkorn.* Dec. 13, 1967-Jan. 28, 1968. Checklist.

1968 Kansas City, Missouri, William Rockhill Nelson Gallery and Atkins Museum of Fine Arts.

 New York, New York, Poindexter Gallery. *Richard Diebenkorn.* May 11-30. No cat.

 Richmond, California, Richmond Art Center. *Richard Diebenkorn.* Dec. 12, 1968-Feb. 2, 1969. Illustrated brochure.

 New York, New York, Poindexter Gallery. *Richard Diebenkorn, drawings.* Dec. 21, 1968-Jan. 30, 1969. No cat.

1969 Los Angeles, California, Los Angeles County Museum of Art. *New Paintings by Richard Diebenkorn.* June 3-July 27. Cat. text by Gail Scott.

 New York, New York, Poindexter Gallery. *Richard Diebenkorn: "The Ocean Park" Series.* Nov. 1-29. Cat.

1971 Los Angeles, California, Irving Blum Gallery. *5 Ocean Park Paintings.* April.

 Palo Alto, California, Galerie Smith-Andersen.

 New York, New York, Poindexter Gallery. *Drawings, 1970-71 "Ocean Park".* Mar. 6-Apr. 1. Cat.

 New York, New York, Marlborough Gallery. *Richard Diebenkorn, The Ocean Park Series: Recent Work.* Dec. 4-31. Cat. text by Gerald Nordland.

1972 Los Angeles, California, Gerald John Hayes Gallery. *Richard Diebenkorn Lithographs.* June. Illustrated checklist.

 San Francisco, California, San Francisco Museum of Art. *Richard Diebenkorn Paintings from the Ocean Park Series.* Oct. 14, 1972-Jan. 14, 1973. Cat. text by Gerald Nordland.

 New York, New York, Martha Jackson Graphics. *Richard Diebenkorn: Figures.* Nov. 28-Dec. 16. No cat.

1973 London, England, Marlborough Fine Art Ltd. *Richard Diebenkorn The Ocean Park Series: Recent Work.* Dec. 5, 1973-Jan. 12, 1974. Cat. text by John Russell. Traveled to Zurich, Switzerland, Marlborough Galerie, Feb. 21-Mar. 23, 1974.

1974 Santa Cruz, California, Mary Porter Sesnon Gallery, University of California. *Richard Diebenkorn: Drawings, 1944-1973.* Feb. 17-Mar. 17. Cat. text by Philip Brookman and Walter Melion.

1975 Los Angeles, California, James Corcoran Gallery and San Francisco, California, John Berggruen Gallery. *Richard Diebenkorn: Early Abstract Works 1948-1955.* Mar. 12-Apr. 19. Cat.

New York, New York, Marlborough Gallery. *Richard Diebenkorn The Ocean Park Series: Recent Work.* Dec. 6-27. Cat.

1976 Los Angeles, California, Frederick S. Wight Art Gallery, University of California. *Richard Diebenkorn Monotypes.* Feb. 1-29. Cat. text by Gerald Nordland. Traveled to Chicago, Illinois, Museum of Contemporary Art, May 1-June 20.

Buffalo, New York, Albright-Knox Art Gallery. *Richard Diebenkorn: Paintings and Drawings, 1943-1976.* Nov. 12, 1976-Jan. 9, 1977. Cat. texts by Robert T. Buck, Jr., Linda L. Cathcart, Gerald Nordland and Maurice Tuchman. Traveled to Cincinnati, Ohio, Cincinnati Art Museum, Jan. 31-Mar. 20, 1977; Washington, D.C., Corcoran Gallery of Art, Apr. 15-May 23, 1977; New York, New York, Whitney Museum of American Art, June 9-July 17, 1977; Los Angeles, California, Los Angeles County Museum of Art, Aug. 9-Sept. 25, 1977; Oakland, California, The Oakland Museum, Oct. 15-Nov. 27, 1977.

1977 New York, New York, M. Knoedler & Co., Inc. *Richard Diebenkorn.* May 7-June 2. Pamphlet.

Collections

Public Collections

Albright-Knox Art Gallery, Buffalo, New York

Allen Memorial Art Museum, Oberlin College, Oberlin, Ohio

Arkansas Art Center, Little Rock, Arkansas

Art Gallery of Ontario, Toronto, Canada

The Art Institute of Chicago, Chicago, Illinois

The Baltimore Museum of Art, Baltimore, Maryland

The Brooklyn Museum, Brooklyn, New York

California Palace of the Legion of Honor, San Francisco, California

University Art Museum, University of California, Berkeley, California

Museum of Art, Carnegie Institute, Pittsburgh, Pennsylvania

Chrysler Museum at Norfolk, Norfolk, Virginia

Cincinnati Art Museum, Cincinnati, Ohio

Cleveland Museum of Art, Cleveland, Ohio

Colorado Springs Fine Art Center, Colorado Springs, Colorado

The Corcoran Gallery of Art, Washington, D.C.

Des Moines Art Center, Des Moines, Iowa

Grand Rapids Art Museum, Grand Rapids, Michigan

The Solomon R. Guggenheim Museum, New York, New York

Hirshhorn Museum and Sculpture Garden, Smithsonian Institution, Washington, D.C.

University of Iowa Museum of Art, Iowa City, Iowa

Los Angeles County Museum of Art, Los Angeles, California

The Metropolitan Museum of Art, New York, New York

The University of Michigan Museum of Art, Ann Arbor, Michigan

The Museum of Modern Art, New York, New York

University of Nebraska, Sheldon Memorial Art Gallery, Lincoln, Nebraska

William Rockhill Nelson Gallery of Art and Atkins Museum of Fine Arts, Kansas City, Missouri

University Art Museum, The University of New Mexico, Albuquerque, New Mexico

Student Association, State University of New York at Albany, Albany, New York

Newport Harbor Art Museum, Newport Beach, California

Neuberger Museum, State University of New York College at Purchase, Purchase, New York

North Carolina Museum of Art, Raleigh, North Carolina

Norton Simon Museum of Art at Pasadena, Pasadena, California

The Oakland Museum, Oakland, California

Pennsylvania Academy of the Fine Arts, Philadelphia, Pennsylvania

The Phillips Collection, Washington, D.C.

Philadelphia Museum of Art, Philadelphia, Pennsylvania

Phoenix Art Museum, Phoenix, Arizona

The St. Louis Art Museum, St. Louis, Missouri

San Francisco Art Commission, San Francisco, California

San Francisco Museum of Modern Art, San Francisco, California

The Santa Barbara Museum of Art, Santa Barbara, California

Stanford University Museum and Art Gallery, Stanford, California

Washington Gallery of Modern Art Collection, Oklahoma Art Center, Oklahoma City, Oklahoma

Washington University Gallery of Art, St. Louis, Missouri

Whitney Museum of American Art, New York, New York

Witte Memorial Museum, San Antonio, Texas

Yale University Art Gallery, New Haven, Connecticut